planet football

planet football

Andoni Canela and Rodolfo Chisleanschi

Prologue by Jorge Valdano
Foreword by Pepe Baeza
Translated by Paul McGrath and Andrea McGrath

First published in English 2007 by Aurum Press Ltd, 7 Greenland Street, London NW1 0ND
www.aurumpress.co.uk

A catalogue record for this book is available from the British Library

ISBN-10 1 84513 288 2
ISBN-13 978 1 84513 288 0

Designed and produced by BLUME
Editorial Director Leopoldo Blume
Design E + E Diseño
Layout María Benavides
Coordination Cristina Rodríguez Fischer
Origination by Scan 4
Printed in Spain by Filabo, S.A., Sant Joan Despí, Barcelona

Prologue by Jorge Valdano

I write this prologue with some trepidation, fearful that my words will fail to do justice to either the beauty of this book or the sentiments which it represents. Who could fail to cherish a book about the worldwide appeal of football in which the words of Rodolfo Chisleanschi complement the photographs of Andoni Canela. One is from Argentina the other from Spain's Navarra region; they use different media to describe football but share the same love of the game.

I have admired Rodolfo as a journalist for several decades and counted him as a friend for several years. He is the classic football-mad guy but, unquestionably, a lucid madman. The text he has written for *Planet Football* is profound, imaginative and sensitive; as one would expect from an Independiente de Avallaneda fan whose fountain pen has a football attached to it. What Andoni's marvellous photographs say to me is that this is a man for whom the world is small but who, wherever he may be, is

always able to make an image that reflects his enthusiasm for football, which, as we all know, is both global and local at the same time. In fact, football is in all places, but it has the rare virtue of unravelling a place's identity. Concealed within every one of his photographs are hidden stories we can recreate in our imaginations. Just as football provides the setting for people's lives, so Andoni Canela's photographs say much more than they show. Congratulations to both their talents for allowing us readers to take a tour around authentic football, and thanks for granting me the honour of having a place in the book.

Some initial warnings. In this book you won't see players like Di Stefano, Pele, Cruyff, Maradona, or any past or present idols. The matches you will see on these pages do not take place in the Maracaná or Bombonera, the San Siro or the Santiago Bernaneu. The balls bear no famous brand-names. Don't expect to see referees either. Finally, as you

turn the pages of this book don't even murmur words like 'tactics', 'marketing' or 'transfer fees'. Nevertheless, the book oozes football from its every pore because it shows us the miracle of a game that grew for a hundred years like a climbing plant until its tentacles spread into every corner of the world. It speaks to us of pure football: as strong as the masses, as profound as culture, as diverse as humanity…

It is easy to imagine that all of the anonymous, even abandoned, pitches that are gloriously reclaimed in these pages have witnessed fierce fights for pride and vengeance. That all the boys shown here running after balls are escaping from who knows what miseries and are in search of who knows what dreams. Or maybe there is just one universal pitch that changes colour to fit in with the surrounding landscape; maybe there is just one ball going round the universe in search of a kind foot to treat it as God intended; and maybe there is just one boy running around the universe to play the most beautiful game in the world. Rodolfo is right when he writes that football has the gift of making us all equals: a Swede, a Cameroonian, a Uruguayan and an Australian essentially feel the same when they score a goal. Thus this is, in its own way, also a book about tolerance. They say that football is, like politics, war by other means. But looking at many of these boys it is easy to imagine that war is for them a fact of everyday life and the football pitch is the place where reality allows them a little truce. If I had a magic wand it would be round like a football. Hey presto! Let there be happiness. It doesn't matter how or where because, as you will see here, football pitches can survive anything. They can be found half way up mountains, they may be parched and ankle-deep in sand or knee-deep in water and awaiting better times. All that is certain is that, for those who still require proof, this exceptional book shows that football is as universal and eternal as a fan's love for his team's strip….

Jorge Valdano
has as played as a professional footballer for various teams in Argentina and Spain. He was a member of the Argentine national team that won the World Championship in Mexico in 1986 and has served as coach for Tenerife, Real Madrid and Valencia as well as contributing to the football media. His last post before retiring from the game was as General Sporting Director at Real Madrid.

Foreword by Pepe Baeza

To travel freely all over the world, enjoying its variety day by day, is a privilege that few of us can hope to enjoy, but for Andoni Canela it is a way of life. I believe that photography is, for him, simply a way of giving creative expression to the knowledge he gains and the emotions he experiences in the course of his travels – a means of expressing in a concrete way his compulsive urge to see what lies round the next bend in the road, and, more practically, an exciting way to finance his passion. Travelling and photography have always gone hand in hand. Not only because the industrial revolution which gave us photography also opened up new possibilities for travel, but also because there is a strong, primary connection between discovering something and revealing it to the public; photography, as Barthes taught us, is the most direct way of showing, of telling others: 'Look at this (I was there).'

Andoni is a contemporary exponent of the tradition that emerged from this connection; a tradition founded by the first travel photographers of the mid-nineteenth century, when photography was still in its infancy. Andoni's work is, in its own way, a continuation of the path followed by Maxime du Camp, Francis Frith or Samuel Bourne, who brought to the West the first photographs of places that it hitherto knew only from literature. As a motivation for travel, this natural curiosity about the world in which we live – and die – has obviously since been overtaken by the needs of business and the appetite for mass tourism. Similarly, since the days of the Victorian travellers with their unwieldy cameras, photography has also become a productive routine rather than a creative pleasure; a means of measuring one's status in terms of the number of holidays taken or journeys made, a useful as well as a subtle, but effective, means of social climbing.

But for travel photographers, for whom the experience of travelling is an end in itself, the taking of photographs offers a means of funding their journeys while also exercising their creativity. They record people, animals, amazing places, dramatic weather, geological phenomena, alien cultures, and in so doing communicate their fascination with the world to others, even if they are sometimes obliged to show these things in ways that others want them to be seen.

This book explores one of the most spontaneous and widely enjoyed elements of contemporary globalised culture: football. Even advertising seeks to exploit the omnipresence of this sport, attempting to convert it into a symbol of understanding between peoples. But the football we see in this book is substantially different from the one portrayed in advertisements. For a start, Andoni truly likes football (he still plays as centre-forward in a team with friends, and some of them occasionally end up with damaged ligaments). It's easy to imagine this photographer's satisfaction when he chances upon a football pitch in an out-of-the-way place. Such discoveries must give him a very strong incentive to break off from his work and take off on yet another quest for evidence that football has found its way to yet another bizarre or unexpected location. Andoni also has other recurring themes that always give meaning to his trips, but that is another matter.

Given that Andoni is a traveller, a photographer and a footballer, this book was almost inevitable. It offers us a poetic vision of exceptional places where one of humanity's most celebrated means of instilling skill, strength and togetherness is passionately practised. Andoni's football is a compendium of spaces that act as meeting places, but which remain as landscapes of dreams when they are empty and forgotten.

Pepe Baeza
is Graphics Editor of *La Vanguardia* magazine and Professor of Photojournalism and Photographic Genres at Barcelona's Universidad Autónima. He is also the author of *For a Critical Function of Press Photography*.

Introduction: The football religion by Rodolfo Chisleanschi

Followers of the football religion, myself included, have their own version of the Creation. We say that the planets are not spherical by mere chance. God made them this way, not square, triangular or egg-shaped, because long before he became a serious guy with a white beard he discovered that nothing satisfied his lucid, and heretically human side better than a kick-around with the angels on the infinite field of the universe. Moreover, as heirs of the ancient astronomers who used geocentricism to explain the cosmos, we believers maintain that there is irrefutable proof of our Maker's preference for our small planet: the flattening of the Earth at its poles is nothing less that His footmark, a plausible theory if you bear in mind we are talking about the most skilful footballer around until the birth of Di Stefano, Pele, Cruyff and Maradona, and therefore a regular practitioner of the 'footstep', the pinnacle of this exceptional game, which consists of being able to manoeuvre the football with the sole of the boot or foot. The only drawback to this skill, clearly, is that it leaves the ball slightly deformed, just as happened to the Earth.

We followers of the football religion have a special ability to recognise each other wherever we go. We can easily distinguish each other without the need for external signs or identifying credentials. The barefooted boy kicking stones around in the Sahara Desert, the Iranian woman who looks out of the corner of her eye at a magazine in which the biggest local football star is shamelessly showing off his bare muscles, the woodcutter in the Peruvian Amazon impatiently trying to tune his radio to his team's game, the well-known writer compelled by an inner voice to put out a cigarette butt with his heel while on the way to the launch of his latest book: we are all part of the same brotherhood, we share the same passion, we speak the same language. There are few places in which human beings are more equal than on the terraces of a stadium or crowded round the TV screen in a bar. There are very few moments in life when we can spontaneously hug a complete stranger without sparing a thought for their name, profession, social standing or cultural baggage: one of these is the sublime moment of a goal. Football is one of very few games that facilitate the instant formation of a team, regardless of language, nationality or religion. One could rightly say that this doesn't ultimately shape humanity's future, as 90 minutes later everyone will continue down the same path that they were following before the fleeting encounter. But one could also argue that giving free rein to our lucid, gregarious and passionate side from time to time clears our minds, lets off steam and makes us more human.

We followers of the football religion know that this marvellous game has two qualities that distinguish it from other forms of physical exercise. One is that you can be tall or short, strong or puny, fast or small, female or male,

child or adult, rich or poor, learned or illiterate, or none of these, and still play without seeming out of place. The other is that we don't need leather footballs, brand-name boots, grass pitches or regulation-sized goalposts to allow ourselves to be infected by this sport's innocuous virus. To really get a feel for football, you can, should even, trying playing it with shoes, slippers or bare-foot; with jacket and tie, in a skirt or stark naked; in the street, on the beach or in your living room, and using anything that passes for a ball. I personally have played memorable matches of something resembling football on sloping or paved 'pitches', or with trees or streetlights serving as makeshift defenders, or in newspaper offices. The 'balls' can be leather, rubber or plastic, made of socks, paper wrapped in sellotape or Coca-Cola bottle tops; but goals were always celebrated with shouts as fervent as in a cup final. Football's massive success is based on the above two qualities. Throughout all human history, no religion has managed to attract so many millions of believers in just one and a half centuries of existence. Maybe this is because none of them has been so universal and generous in providing the same moment of happiness to anyone, and I mean anyone, who enjoys taking a peep inside its fascinating world.

We followers of the football religion keep unmissable appointments, like pilgrims to Santiago de Compostela we congregate, spiritually if not physically, at the same point on the planet with varying frequency. We are obviously aware that such occasions are not just about a game; they also, for example, encompass mult-million-pound businesses, top-level politics and an excuse to stir up nationalist sentiment. This evident manipulation, expertly arranged by managers, statesmen, businessmen or the media, encourages those who see football as the origin and consequence of many social ills, but they miss the point that, as the Argentina writer and journalist Rodolfo Braceli rightly states in his book *We Are Football*, this game only 'mirrors reality' without actually creating or modifying it. We acolytes of this faith, who practise it in the most remote corners of the world without asking for anything in return, acknowledge this trickery and try, in part, to avoid being duped, but we are never able to resist the magnetic lure of joining the pilgrimage. At best we can say our penance, and admit that the vast majority of the followers of this creed are sinners.

We followers of the football religion have our own version of the Apocalypse. We affirm that once God became a serious guy with a white beard, He stopped having his Sunday kick-abouts with the angels. But He occasionally remembers the good old times and is tempted to take it up again. The last time He used the Earth to take a penalty He caused a cataclysm that wiped out the dinosaurs. And nobody can say with certainty that He has hung up his boots for good…

the ball

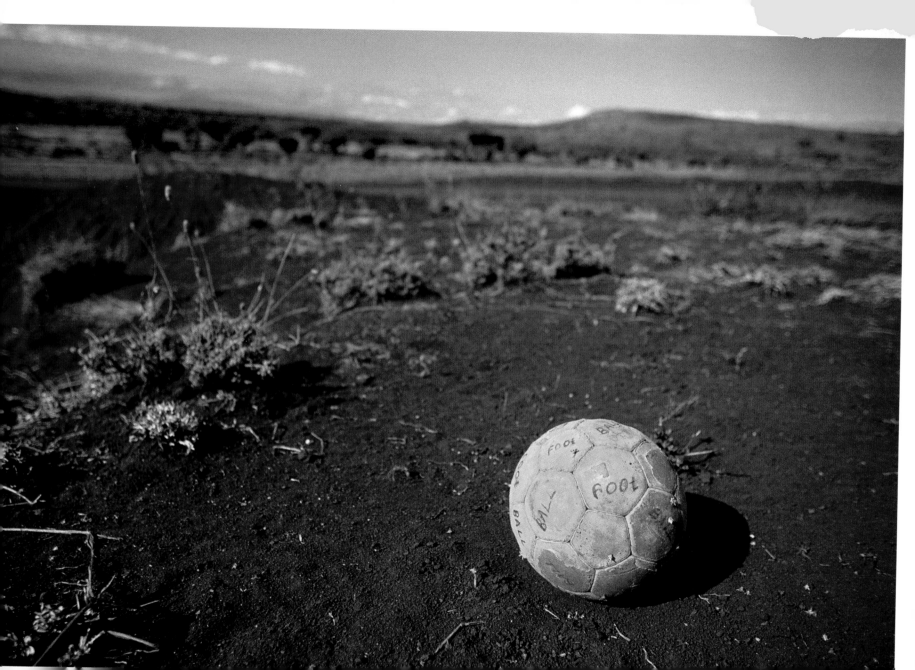

Cipriano Fernández's life was turned upside down the day he was told that he had been a doormat in a previous life. The person who made the assertion, one of those travelling fortune-tellers who set up their stalls in squares or parks on public holidays or market days, was simply acting on the evidence of her own eyes. For it was immediately clear to anyone who met Cipriano that his self-esteem had long been virtually non-existent and the fortune-teller, who genuinely believed in reincarnation, was simply stating what she believed to be obvious. The result was that Cipriano's opinion of himself fell to a new low. Not only was his life grey, lonely and complicated, but now it had become clear that his fate had been predetermined. It was all just too much to bear for shoulders than were already collapsing under the weight of constant misfortune. Cipriano took refuge in drink, and soon you hardly ever saw him sober, except on Tuesdays and Thursdays, when he joined his former team-mates from the town's football team to kick around an old discoloured ball and recall glorious afternoons.

He remained in this state for several months, until one Sunday morning something dawned on him: though he had to accepted that he was the reincarnation of a doormat and that there was nothing he could do about it, he could do something about his next life. He rummaged through some old books until he found one which explained what people could do to improve their chances of being reincarnated in a form that would give them a better

chance in their next life. He didn't find any definitive answers but he did make one crucial decision: he would come back as a football. He could not, of course, be sure that he would achieve enough in the remaining years of his current existence to make up for 49 years of bad behaviour and ensure a favourable outcome, but at least he would give up drinking and smoking, clean up his appearance and start treating people nicely. That night, for the first time in many years, he got into bed with a smile on his face.

Over the days that followed he imagined his shiny leather skin bouncing on newly mown grass; he dreamt of being an object of desire for the 22 players and a magnet for the eyes of hundreds, even thousands or millions, of excited spectators; he fantasised about being guided by a midfielder making a inspired geometric pass, caressed by the boot of a skilful winger, kissed by the instep of a centre-forward, enveloped in the swollen belly of a welcoming net Gratified by the imagined applause of overjoyed multitudes, Cipriano seemed to have become a new man, different, full of vitality. And then, one Thursday night, after having a game with the old boys, a shadow fell across his thoughts. Just a few minutes into the game that was being played out in his imagination, the brand new, shiny ball that was him fell at the feet of a huge and ungainly defender who unceremoniously booted him over the touchline. Floating in the dirty water of a well on the edge of the

Previous page

Ngorongoro Conservation Area, Tanzania
This is the home of elephants, rhinoceroses, buffalos, antelopes; zebras, lions,. leopards, cheetahs and wild pigs. The ball is ready on the centre spot; the daily game is about to begin in nature's paradise.

field, he waited patiently for them to come and get him, but a few minutes later he heard the roar of the crowd and came to the conclusion that they had given him up for lost and replaced him with another reincarnated soul. Nobody was paying him any attention, he had been totally forgotten. The following day he was found slumped over a bar table.

It took several weeks for Cipriano to return to the idea of *à la carte* reincarnation. It happened one afternoon, while he was passing a school. He saw a group of boys playing with a ball made of paper and rags. In an Instant he decided that he would return in his next life in the form of a improvised football in the slums; a ball that did not bounce, a ball that was not embellished by logos or hand-stitching, a ball that would never be endorsed by the international organisations; a spontaneous ball, put together to meet an immediate need; a ball whose role was to bring moments of joy to needy places. He slept well that night, and for the next three nights as well. But then he passed by the same school again and through a hole in the wall he saw the remains of the schoolkids' ball, blown into a corner by the wind, neglected and forgotten, the paper and rags were no longer a ball but just a few more pieces of squalid rubbish. When the bar owned saw Cipriano coming in that evening he had a double whisky poured and ready before Cipriano had even said what he wanted.

This time Cipriano was deeply depressed and almost constantly drunk for several days before things took a turn for the better. By chance (or an astonishing and unexpected stroke of good luck) he came across a photograph from his childhood. There he was, proud and smiling, wearing short trousers and scuffed canvas shoes, with his arms akimbo and his right foot placed firmly on a football made up of hexagonal sections in the colours of his favourite team.. Memories of that first leather ball came flooding back: how it had been his faithful companion in adventures on the uneven fields next to the railway tracks, how it had become a physical extension of his body through short winter afternoons and endless summer days; a constant presence as he lay dreaming during siestas under the courtyard tree or at night in the bed he shared with his younger brother. In that moment he knew that his search had come to an end: he would come back as a football, but not just any old ball, rather the first and inaugural one, the one that opens the tap of hopes and dreams, feeds the imagination, and stays inflated when all others get punctured, the unforgettable one.

So many decades have now passed, that the customers at the bar no longer miss Cipriano; but when the see him strolling by, like a ball sliding over wet grass, they can't help but feel happy for him. They know that with every passing day he is getting closer to nirvana.

the pitch

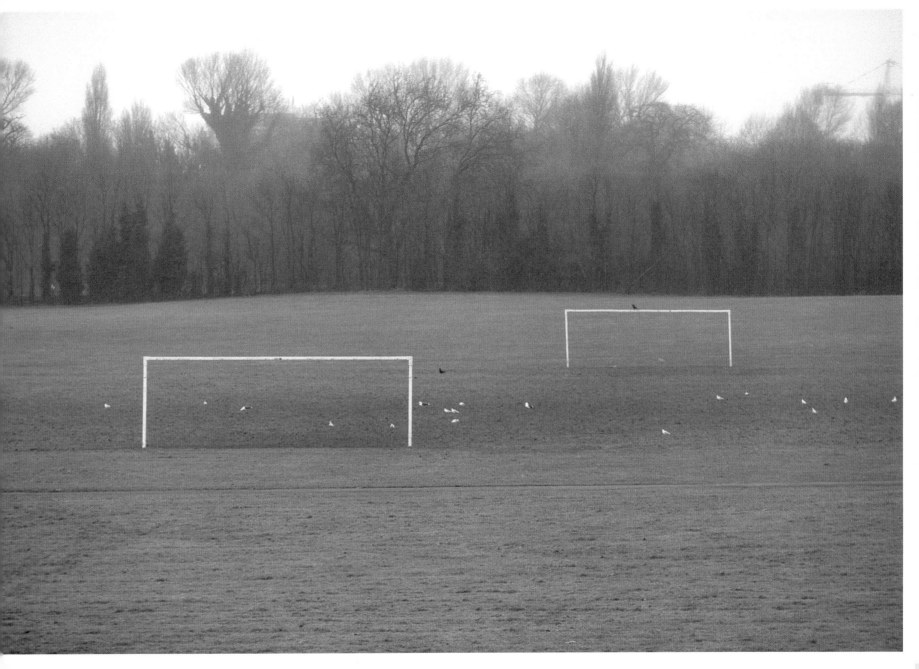

If football is the ideal game (an obviously subjective but perfectly valid opinion) I have always held that its field of play should reflect this; a perfect space in which to stage all the arts, display all the knowledge and practice all the skills associated with the game; an immaculate and pure area where enjoyment of the game surpasses all other pleasures and eclipses all problems; above all, a place that is unspoiled. By unspoiled I do not mean that no man or beast has ever set foot on it, but that it has never been sullied by such coarse things as rules, regulations and laws or, worse, tarnished by advertising hoardings, electronic scoreboards or TV cameras.

After musing on the subject for a very long time I began to form a mental picture of this ideal, perfect pitch that had begun to take shape in my imagination. Over time, I perfected its design and orientation, its surface, atmosphere and appearance, as well as the way in which it would be used. I can now say that this pitch actually exists, I have played countless games on it, it has been the scene of my best performances, my biggest victories and most disastrous defeats.

This is a fairly detailed description of it. To start with, it is fundamental to the perfection of this ideal pitch that t doesn't have any boundaries. The ball can never go out, there are no church walls to cut short chases, there are no rivers or lakes, woods or hedges or fences to obstruct a player who breaks away with the ball. Played in this arena, football is never interrupted; no one has to wait for the night watchman to turn up next door to retrieve the ball and toss it back over the fence, or to worry that an irritable neighbour will confiscate it rather than returning it. There is no danger of some dimwit kicking the ball into a tangle of scrub and losing it. The absence of lines of demarcation also facilitates the free participation of players. On the ideal pitch the perverse habit of starting the game with one set of players and then substituting others is abolished, there is no distinction made between those who play and those who watch. Here, anyone can play who knows how and wants to join in. It is just a matter of asking which team is short of a player and then starting to play – one team, if not both, will always be short of at least one player. As a result, there is no more anxiety for the person on the sidelines,

Previous page
Richmond, London, England
In the land of football's birth nobody is ever far away from the game. Neither are the gulls, which take advantage of the morning solitude to appropriate the well-kept turf.

waiting impatiently for his turn to get out onto the pitch and longing for someone else to score a goal, get tired or even break a leg.

Given its infinite extent, the ideal pitch leaves no room for excuses. The players who feel most comfortable on flat and manicured turf will find a lawn across which they can glide with gazelle-like agility; on the other hand those who prefer muddy terrain the better to dribble the ball will surely find a suitable quagmire. Those whose feet are hardened from walking barefoot across deserts will seek out a parched plot of land covered with pebbles; those who are accustomed to high altitudes will be able to climb a few metres and show off their speed while others gasp for lack of oxygen; meanwhile, young men who have mastered the art of ball control in the cluttered streets will give classes amid urban debris. Thus the ideal football pitch embraces all climates and landscapes, the game is played, at one and the same time, in the snow and under monsoon conditions; in gentle autumn breezes and wild spring gales, in the tropics and on the highlands.

Finally, since its dimensions allow it, the ideal pitch is able to host multiple games simultaneously. For example, while North faces South and East contends with West, Southeast will be challenging Northeast and North-northeast asking for a rematch with South-southeast. This opens up an infinite number of possibilities, because, when different games momentarily come together on the pitch, anyone who wants to can transfer from one team to another without any need for negotiations, agents, managers or contracts.

By now, some readers may be asking where the goalposts are, how do you score a goal, who's in charge of the scoreboard, where do the spectators go, how much does it cost to get in? I'm sorry to tell those people that they really have missed the point. Goals signify results: victory and defeat, euphoria and dismay. Granted, these are all ingredients of football, but not the most transcendental or fundamental. That is why my pitch is ideal. Because on my pitch, free from incidental interruptions, commerce and primitive passions, football shows the beautiful purity of its essence. Here there is only a game, nothing more than a game. You are all invited.

the team

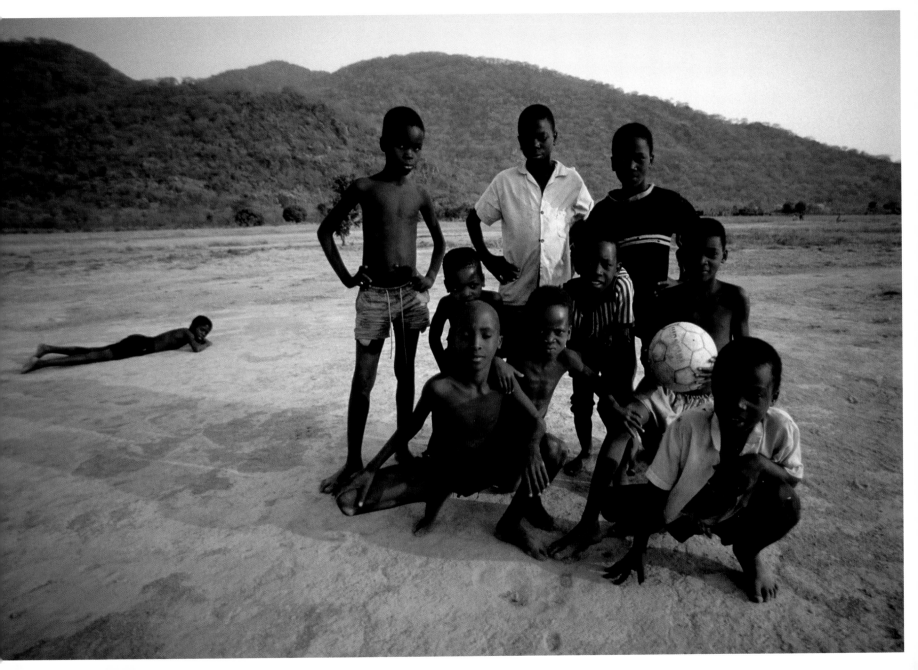

His hair, lank, jet-black and shoulder-length accentuated his weak frame He had pronounced cheekbones, sunken cheeks, deep-set eyes, matchstick arms and legs not thick enough to keep up a pair of socks. His whole appearance was feeble. Standing barely a metre and a half high Iñaki was was the personification if skinniness. If you saw him walking down the street, confident enough, but sticking close to the wall, it was easy to get the impression that he was rather fragile. But anyone who leapt to that conclusion would have made a big mistake, probably because they didn't know Iñaki's personality. You had to hear him talk. His voice was loud and clear, scathing, incisive, endlessly complaining, but at the same time compelling because of its owner's will-power, optimism and vitality. But above all, you had to see Iñaki play football, because there, on the pitch, his personality was openly on display. The subtlety with which he controlled the ball contrasted with the aggression exuding from his every pore, his fiendish speed seemed to be his way of escaping from the frustrations of a difficult life, and the urge for justice fed a rebellious spirit which could flash into a rage that vanished as quickly as it had come.

With such an array of qualities it was a easy to assume that Iñaki must have been the undisputed leader of his team, an amazing leader, whatever way you look at it. it was difficult to believe that such authority could emanate from such a weedy body, and even more difficult to believe that so much football could come out of something so small. Iñaki did everything well: he played well, ran the length of the pitch, helped out in defence, marshalled his team-mates, had good touch and movement, and he knew where the goal was. Outrageously skilled, he was able to make the ball obey even the slightest hint from the trainers which he wore when he added to his endless range of dribbling skills every afternoon. There were two party pieces that he would always repeat. The first one started off with his left foot on top of the ball, then, rolling it forwards a little, as if just showing it to the defender, he would swap feet in the blink of an eye, using his right instep to send the ball to his rival's left, then go round the other side to collect the ball and leave the rival staring at the place where the ball had been just a second earlier. The other one was even more spectacular: when he was challenged to a tackle he would use his heels to roll the ball up and flick it over the head of his disoriented adversary, then control it with his instep once he had gone round the defender. When he showed off these skills even referees would come up and give him plaudits.

Iñaki obviously wasn't the only member of that team. He was the pearl, but the rest of the necklace also shone, each member with his own sparkle. At the back of the defence, Pablo was another example of how intelligence can more than make up for physical shortcomings. Barely a few inches taller and a few kilos heavier than his team-mate and friend, his timing was impeccable,

Previous page
Mkandowe, Malawi
Excitement, rapture, ferocity, distrust, seriousness, fear, even indifference.
A true team expresses all emotions.

a fundamental factor that distinguishes first-rate defenders from the rest. The astuteness with which he could anticipate opposing moves meant that he didn't have to rely on meeting opposing strikers in head-to-head clashes, encounters which he was always bound to lose.

But Pablo brought much more to the team than his abilities as an excellent centre-back. He brought his love for life, his permanent laugh, his playacting, his fantastic ability to mimic the most varied range of voices and sounds. There was nothing funnier than sitting around the table, looking over at him and listening to how his mouth 'opened bottles', 'lit matches', 'opened soft drink cans' or perfectly imitated footballers, managers, commentators or politicians, always under the watchful eyes of his inseparable companion, a black dog whose gentle and tender gaze only friendship or love can explain.

Piranha, the centre-forward, laughed at Pablo's antics more than anyone, except when he was in a bad mood. All centre-forwards have moods which are largely determined by the number of times the ball rippled the back of the opponent's net in the last game, but Piranha took moodiness to another level, always oscillating between being on the verge of a booming laugh and launching into a malicious insult. Such ambivalence, to which was added non-existent manners and personal hygiene, made him an unbearable companion for long periods or on trips. Happily, his obstinacy,

strength, bulk and the power of his shots made him even more unbearable to the opposition defenders.

The one to steady the ship was called Campitos. He was in charge of maintaining balance on the pitch, always ready to lend a hand to whoever needed it, and to call for pause and reflection off the pitch, if he felt that the laughter, complaints, exultations or squabbles were getting out of hand. Campitos, the oldest of the group, couldn't emulate Iñaki with the ball, nor did he have Pablo's timing and positioning, or even half of Piranha's potency, but you only had to see the calmness he exuded in the dressing room to realise that he knew enough about life, and that was more than enough for him to get his voice heard.

That team won many matches and a few titles, but, of course, it wasn't invincible. There were dreadful afternoons in which Iñaki's tricks didn't come off, Campitos lost concentration, Pablo's sense of orientation failed him or the goal insisted on dodging Piranha's missiles. But even on these grey days it was a pleasure to watch them play, because in every chase, every turn, every shout, every pass, those guys were the embodiment of pure football.

One supposes that, out of vanity if nothing else, they would also have enjoyed standing back and watching themselves play. But they never got the chance, because – and perhaps I should have made this clear earlier – the players in that magnificent team were all blind.

Chitwan National Park, Nepal

Asian buffalos have grazed these meadows to the south of the Himalayas for thousands of years.

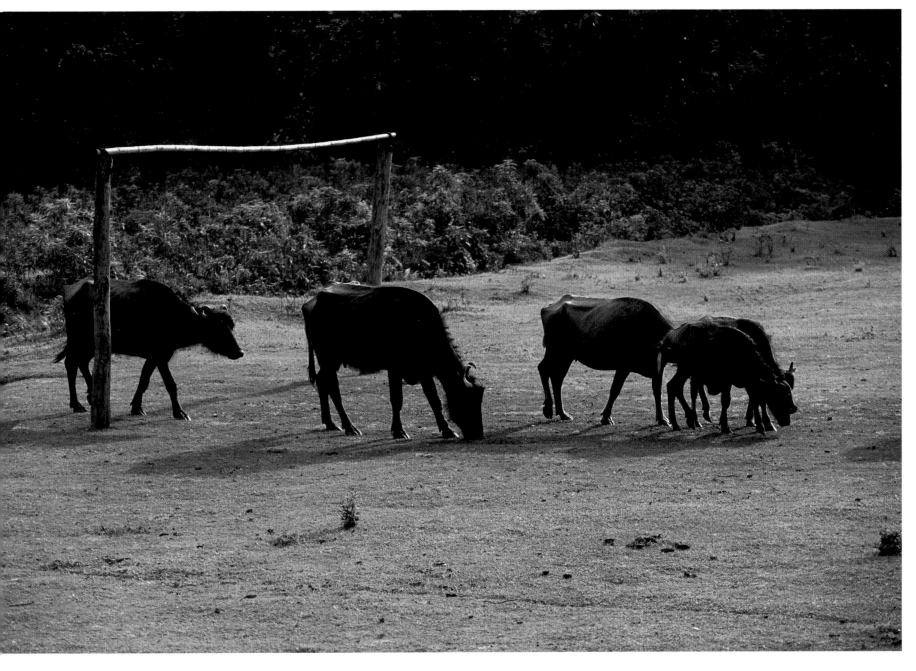

Hanga Roa, Easter Island, Chile

The goalkeeper is a tiny, fragile island in the vast gulf of the goalmouth. But the ball sails unerringly into the safe haven of his hand, which rescues it from being stranded in the shallows of the net.

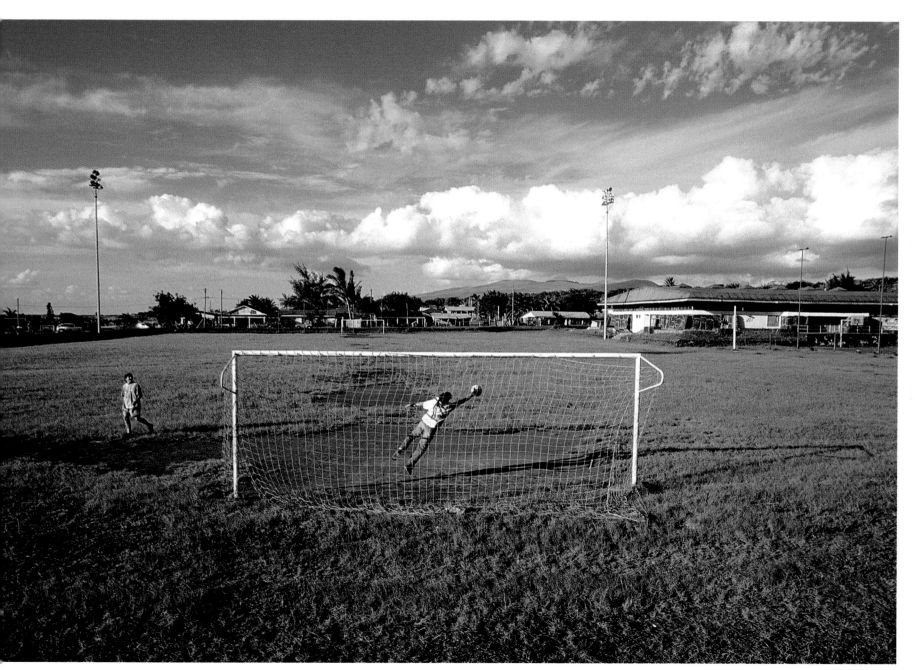

Tapiche, Colombia

The perfectly poised body, the arms outstretched like a tightrope walker, the cheeky tongue sticking out between the lips, the gaze firmly focused on the ball that appears to be glued to the foot – all suggest that a gifted player is in the making amid the vastness of the Amazon.

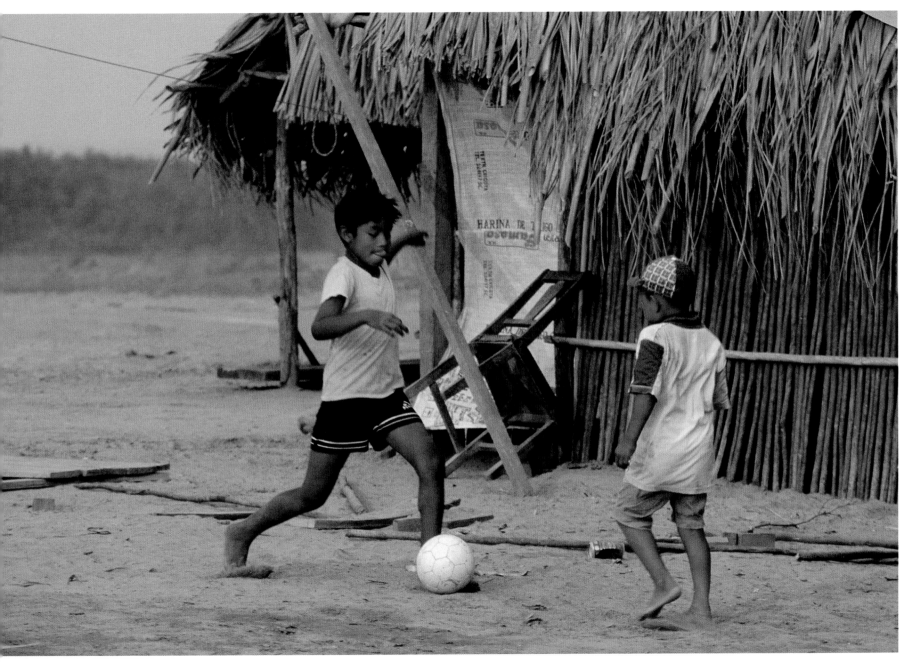

Soria, Spain

The poet Antonio Machado once wrote of the:

'...fields of Soria,
Peaceful afternoons, violet-covered mountains,
Riverside poplar groves, green dream
Of the grey dream and drab earth...'

Were he writing today, he might also mention the three white posts that frame the landscape.

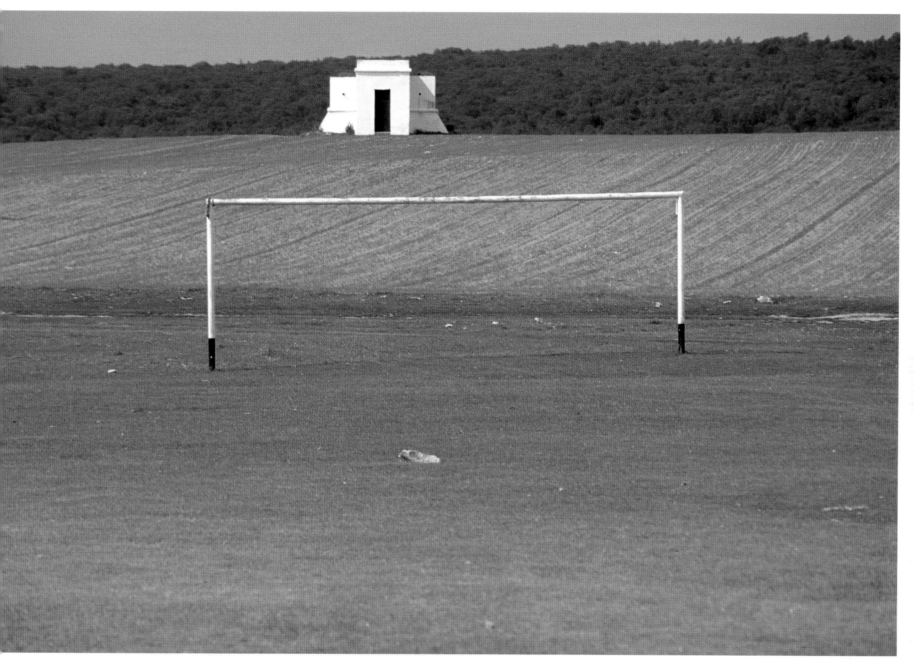

Kauai Island, Hawaii, United States

The central part of this island gets more rainfall than any other place on the planet. This abundance of water supports tropical forests, coffee and sugar cane plantations... and grass on which the kids can play.

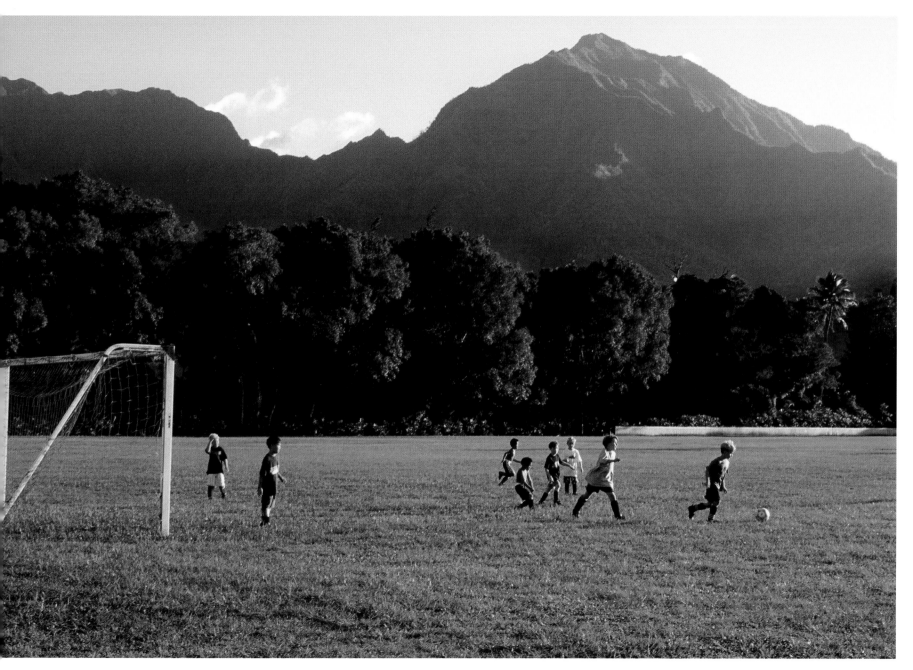

Santa Cruz Island, Galapagos, Ecuador

Sunday is the day for meeting up in the square where people gather and exchange the latest gossip while, in one corner surrounded by trees and lampposts, a game is underway.

Following pages (left and right):

San Martín de Tipishca, Peru

During the rainy season the football pitch becomes a mooring place for boats. Water dominates this landscape where the Marañon and Ucayali rivers meet to form the Amazon.

Sahara, Morocco

The wind shakes the palm trees in the oasis and the air is filled with clouds of dust and sand. No goalkeeper can stop a desert storm.

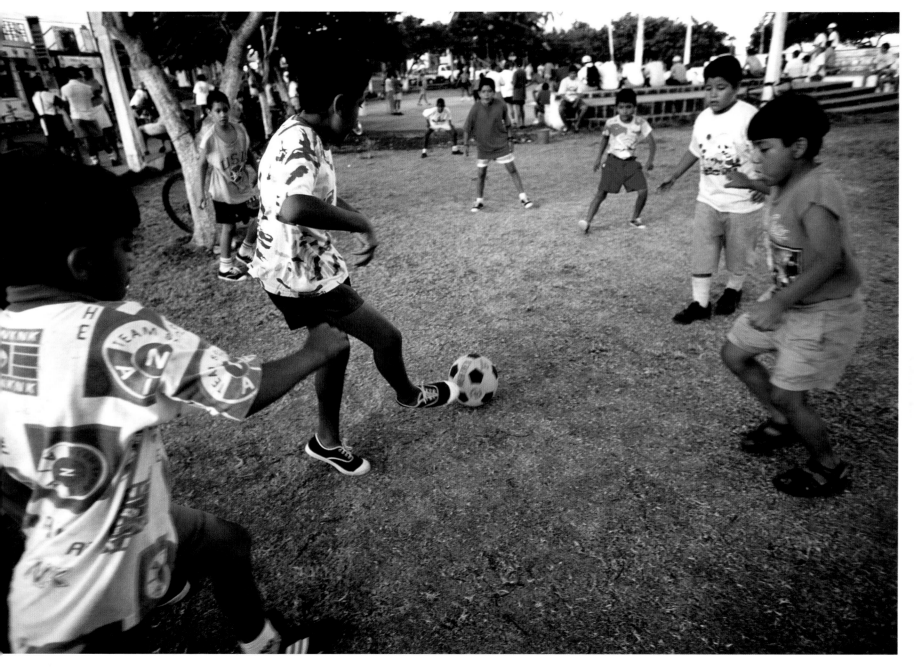

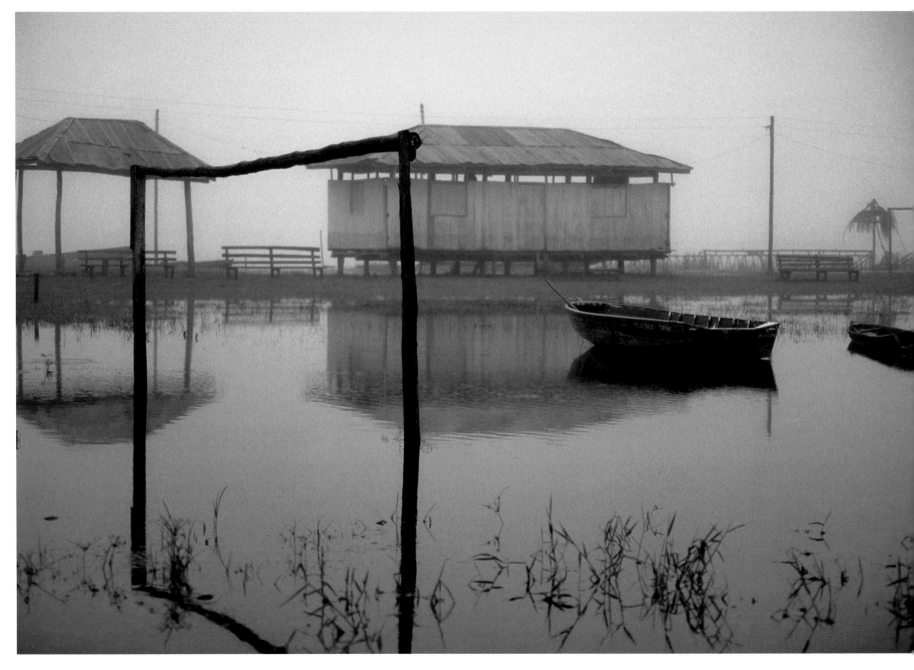

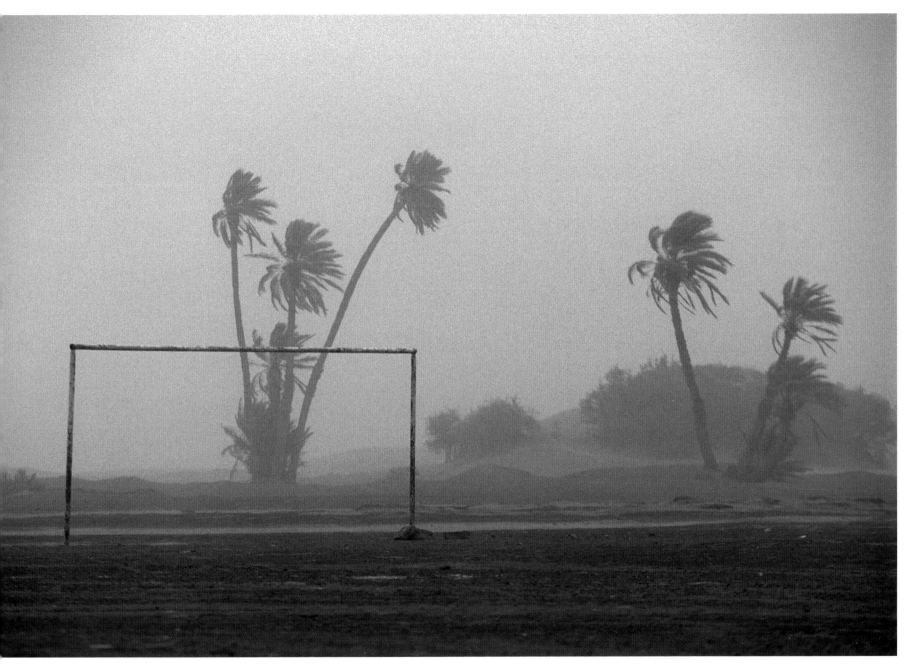

Cefalú, Sicily, Italy

The washing strung out to dry, the golden light, the sensation of heat that is almost physical, the sense that life revolves around football and the beach. This must be the Mediterranean.

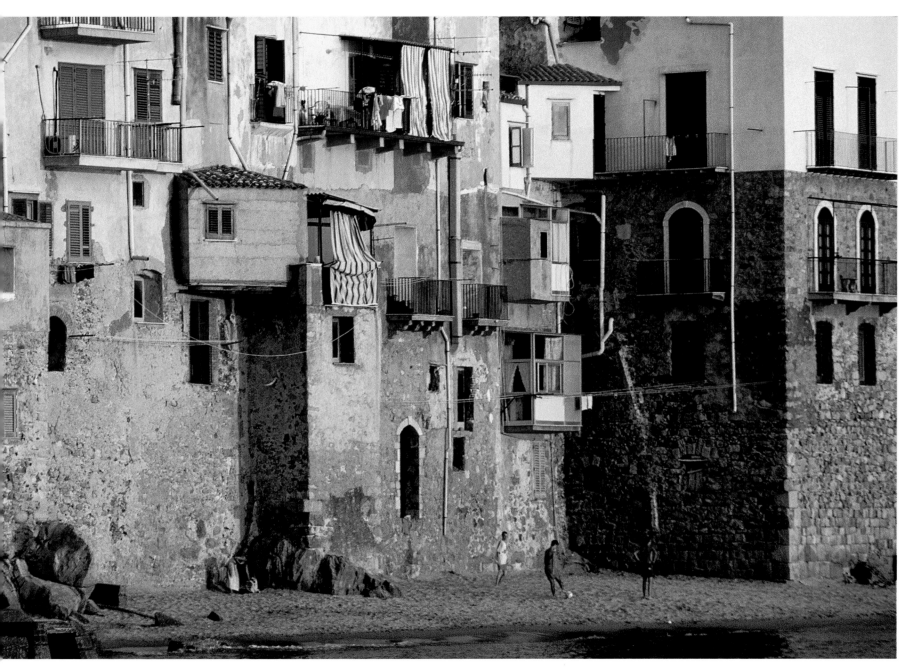

Ngorongoro Conservation Area, Tanzania

The players are oblivious to the surrounding landscape, to the absence of rain which has left the ground parched, even to the clouds and the sun. All that matters to them at this moment is the ball.

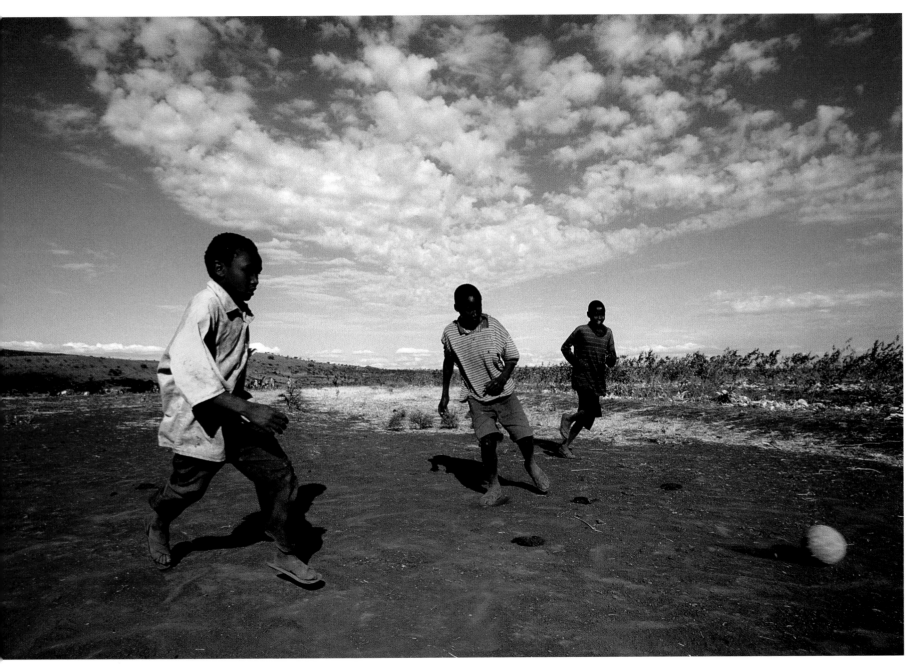

Lekaroz, Navarra, Spain

The monks of the Capuchin convent have sung matins but the morning mist still hasn't lifted. It's still too early for football in the Baztán Valley.

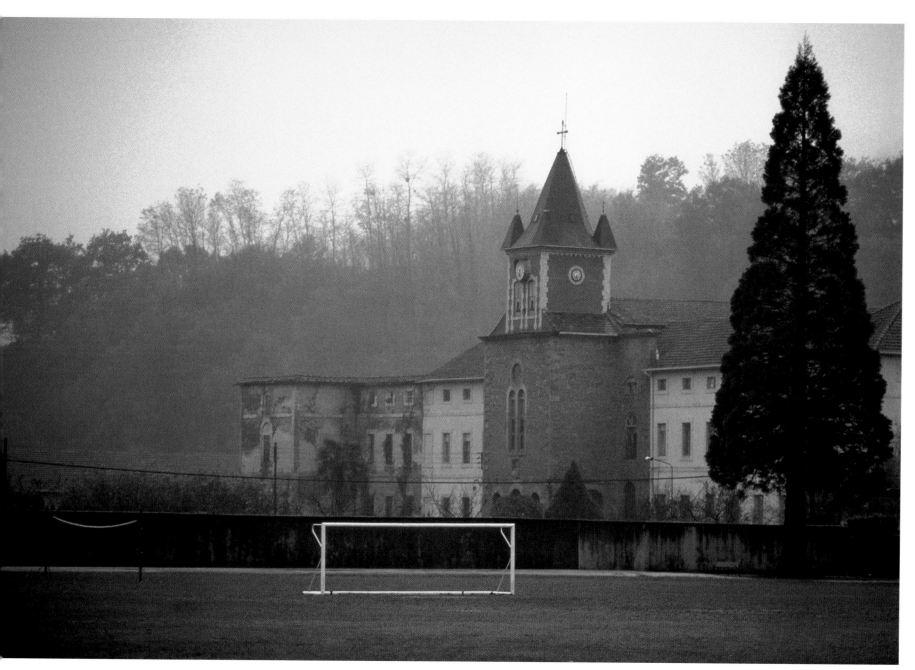

Kribi, Cameroon

'What's going on?' 'Why are we losing?' 'Why can't you get your act together?' Explanations don't carry much weight when defeat looms.

Following pages (left and right):

Fons, Languedoc-Rousillon, France

The goalposts may be small, but the loose net at the upper-righthand corner suggests that sometime in the past someone has fired in a great goal.

Coxen Hole, Roatán, Honduras

A picture of a white, palm-fringed beach marks the target for the children at the John Brooks School.

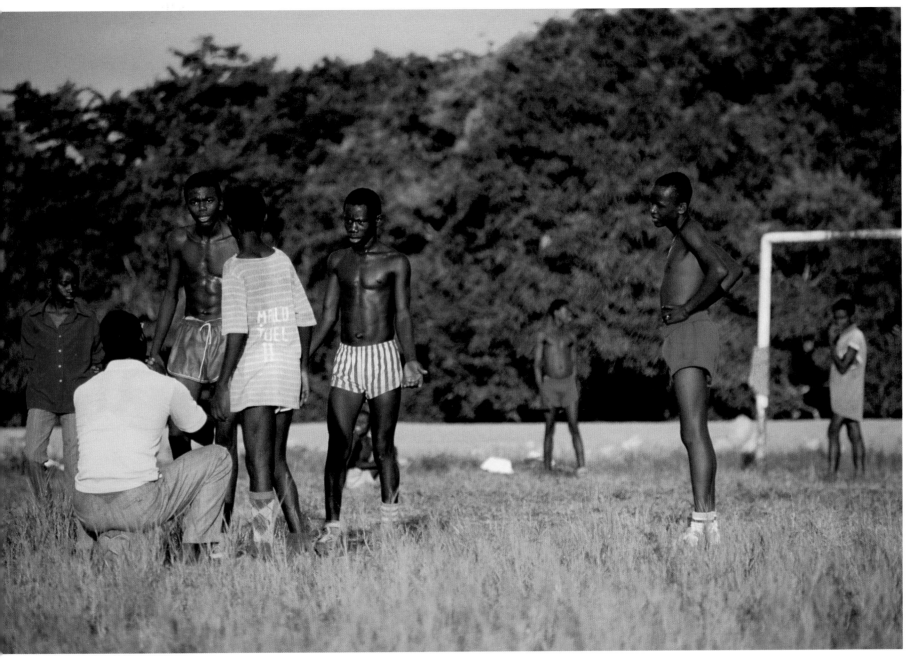

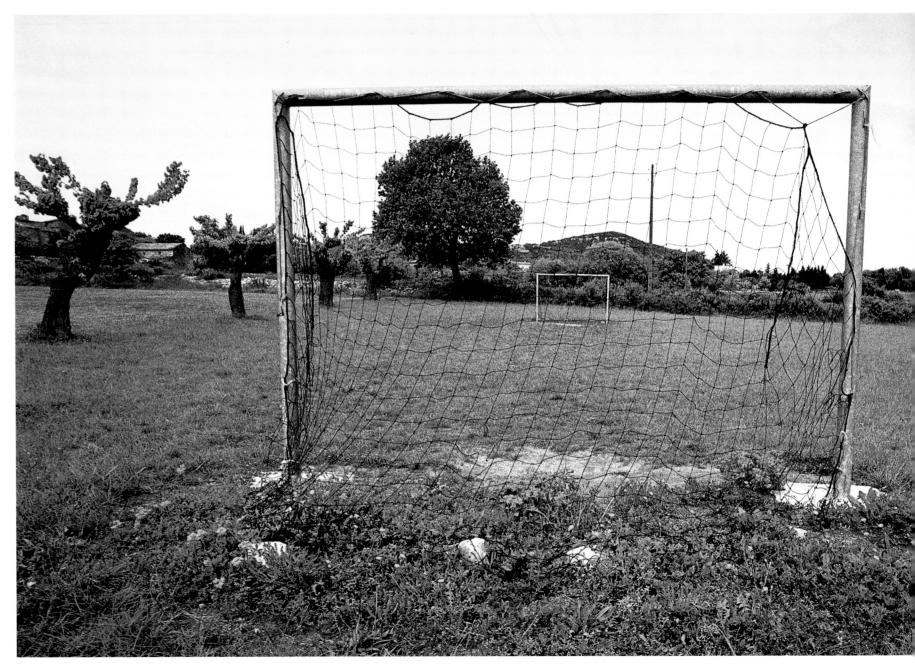

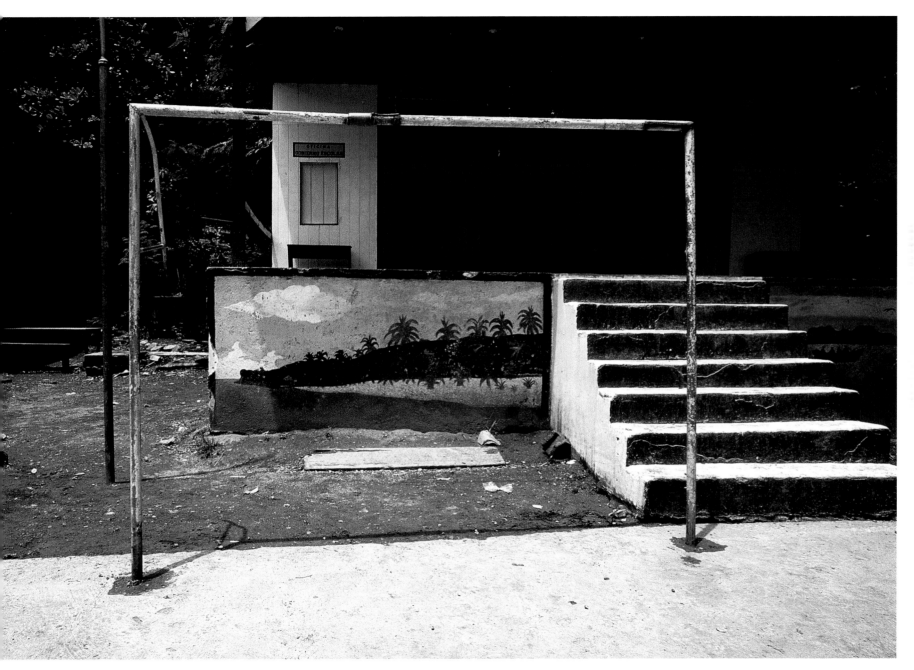

Zagora Valley, Morocco

A family group hurries past a bare, deserted pitch. If the kids miss the chance to play on this one they will face a 52-day trek across the Sahara to Timbuktu before they find another.

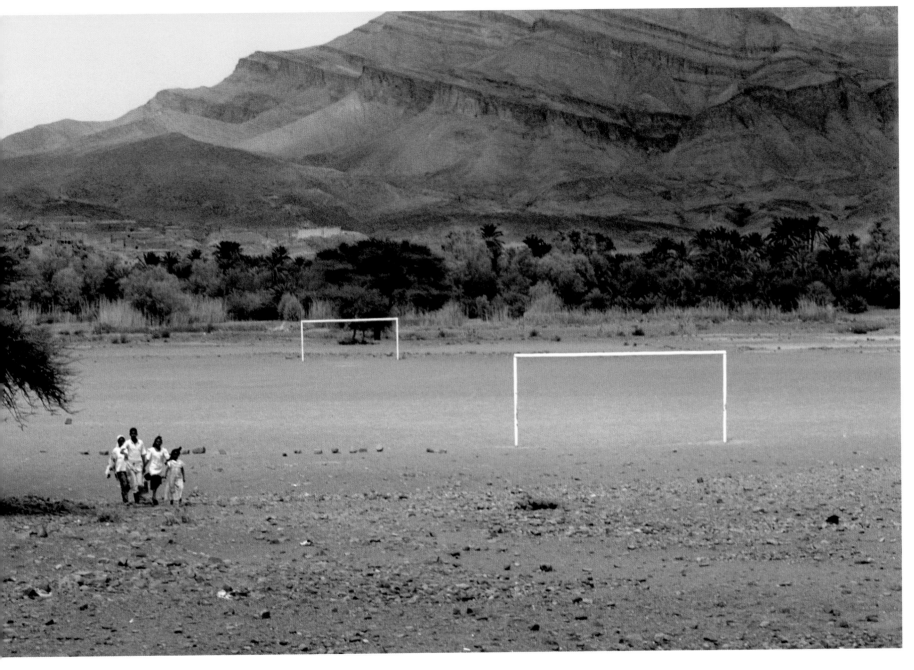

Valle de Savegre, Costa Rica

The site doesn't look ideal and they are going to make a mess of their clean clothes, but when school break time comes round there is nothing that cheers you up more than a kick-around with your friends.

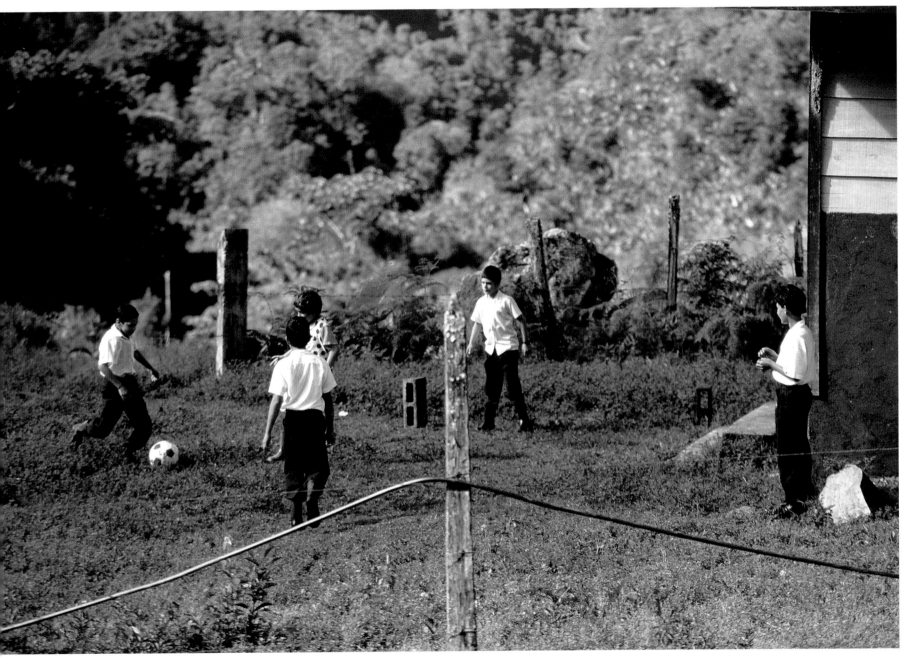

Viver i Serrateix, Catalonia, Spain

Football didn't exist in the 11th century, so one presumes the goalposts were a later addition to the Santa Maria monastery. The monks back then didn't know what they were missing.

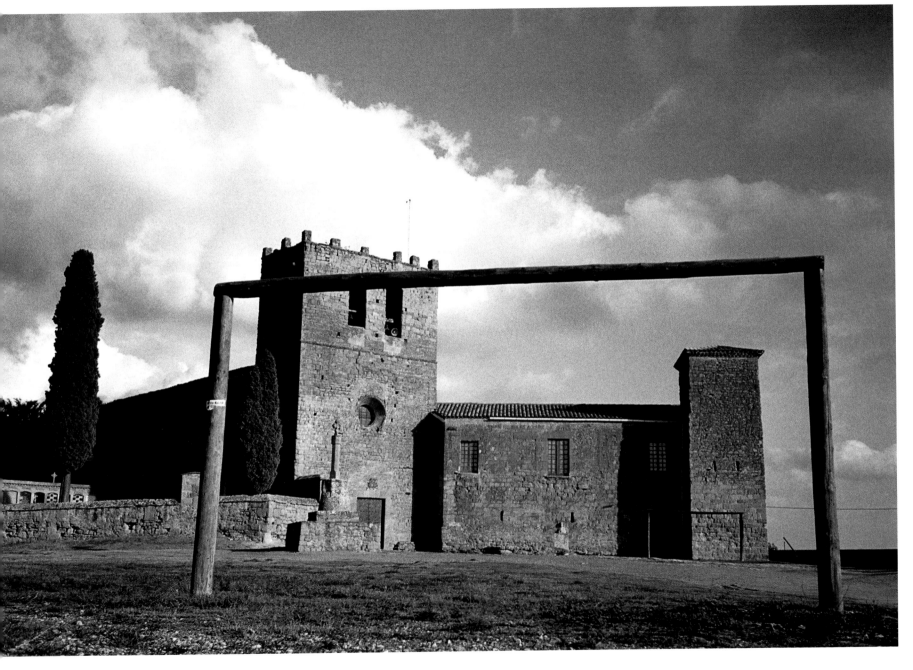

54 · 55

Khajuraho, Madhya Pradesh, India

An impromptu game with a tennis ball and bushes for goalposts is of far greater interest to these kids than the erotic carvings which decorate the Chandela-dynasty temple in the background.

Following pages (left and right):

Guernica, Basque Country, Spain

Youthful speed and agility may have been lost along with the hair, but for the true enthusiast the urge to play remains as strong as ever.

Arguineguín, Gran Canaria, Spain

Millions of years ago a volcano spewed lava across the site, but wind and water eroded it and the drama is now confined to the events that take place on the pitch.

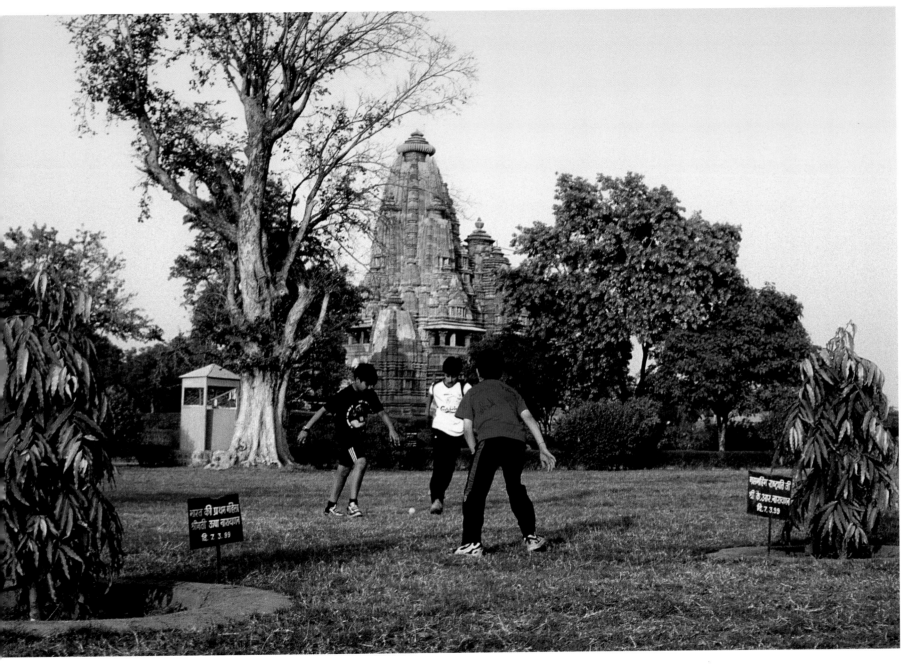

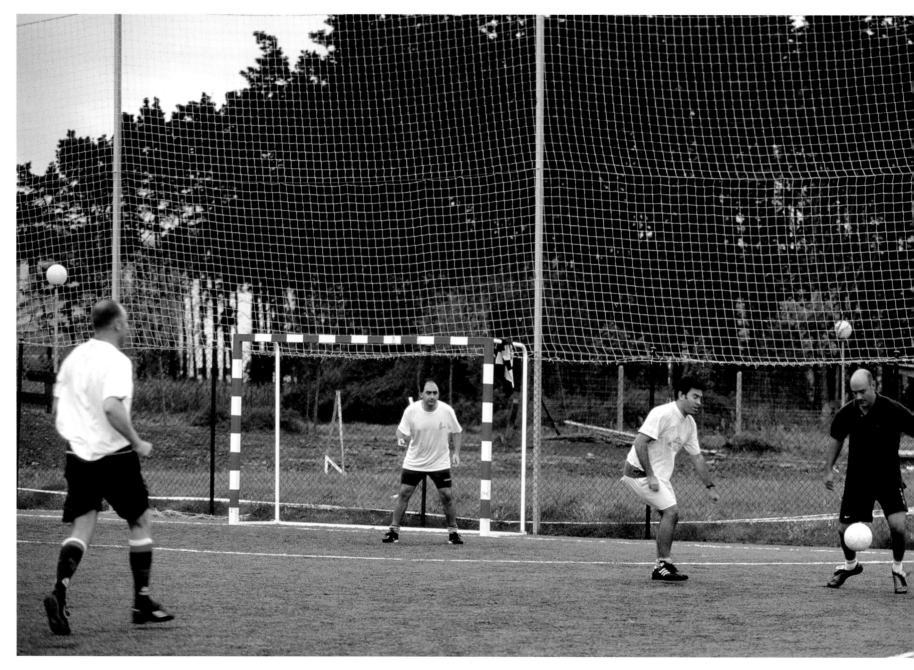

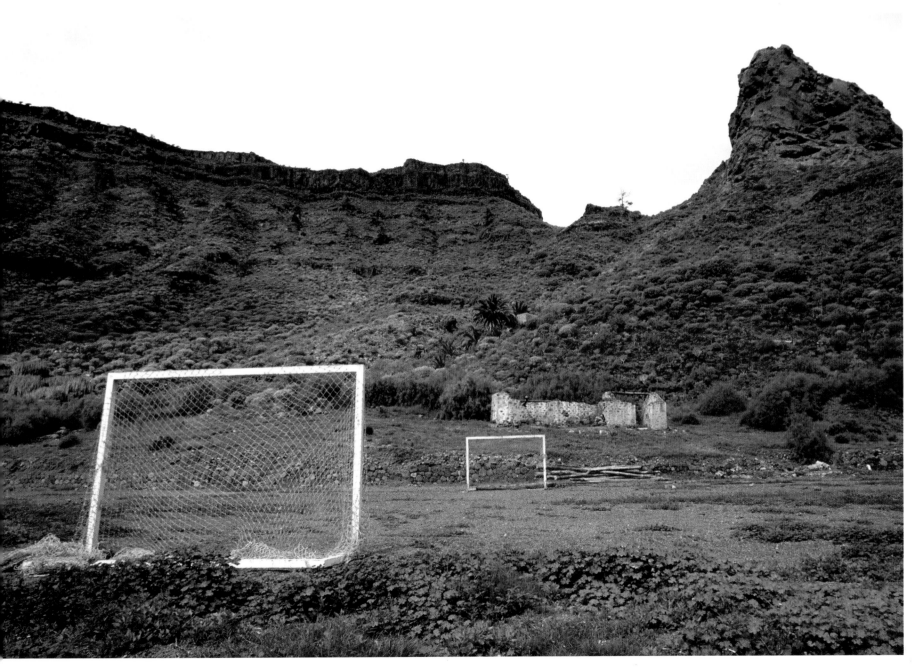

Arusha, Tanzania

The rules go out the window when there is the danger of a breakaway. Football's little tricks are soon picked up in games like this where, as there is no referee, histrionics are pointless.

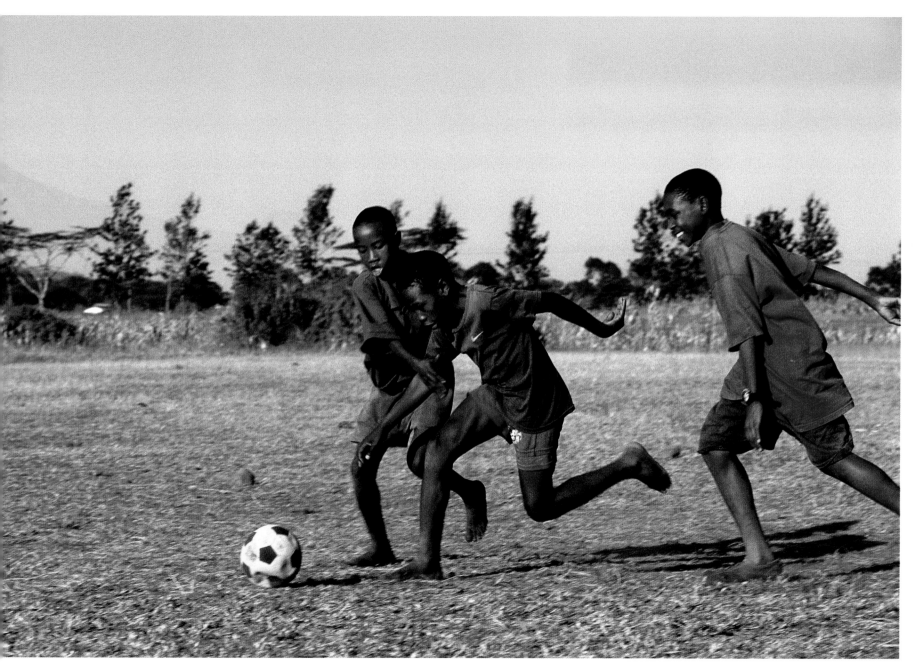

Viver i Serrateix, Catalonia, Spain

A road sign, some electricity cables, a bale of hay and the mountains on the horizon are framed by these lonely goalposts in the Spanish countryside.

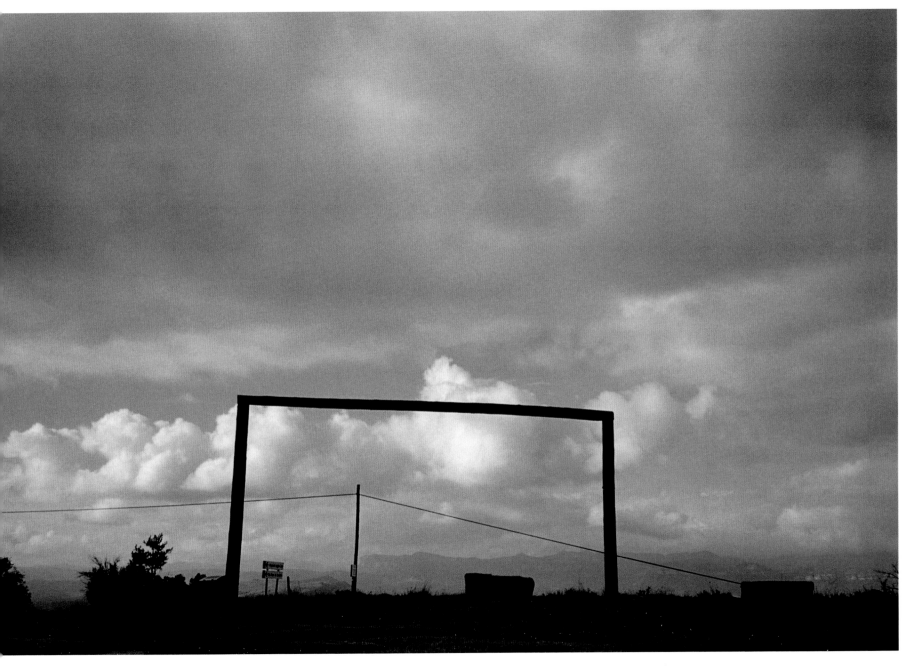

Nyika Mountains, Malawi

Only when the ball is trapped is its behaviour predictable on the uneven terrain of the savannah which is more suited to gazelle races than football. Even so, there is never a shortage of people willing to try and prove otherwise.

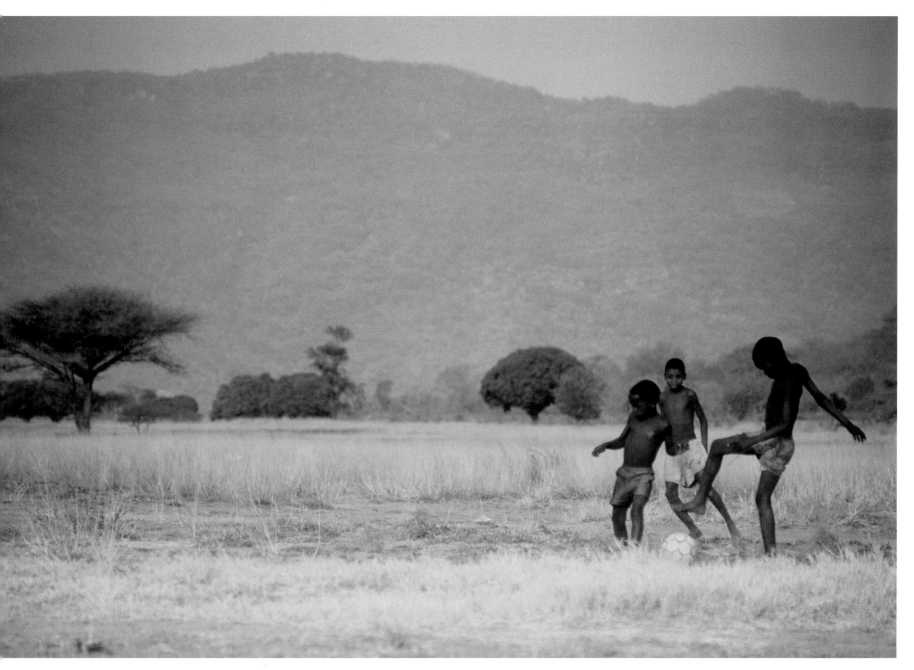

Villa de Leyva, Colombia

An opposition player has broken away and is bearing down with the ball at his feet. For the goalkeeper it is time to tense the muscles and bend the knees, everything is up to him now, though he must wish that the guy on the left would lend a hand rather than just standing there leaning against the post.

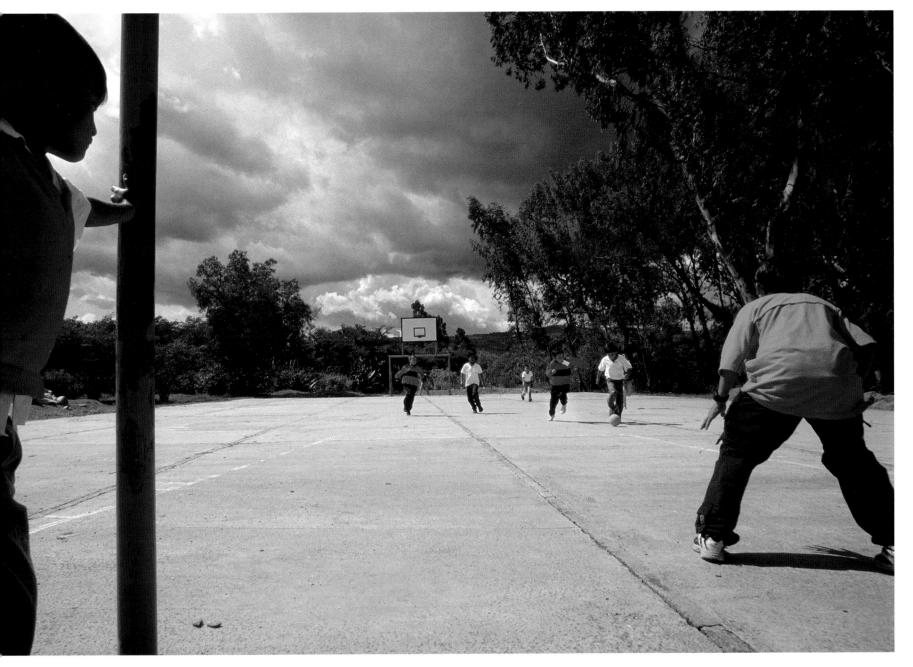

Merzouga, Morocco

The only spectators here are the billions of grains of sand in the surrounding dunes.

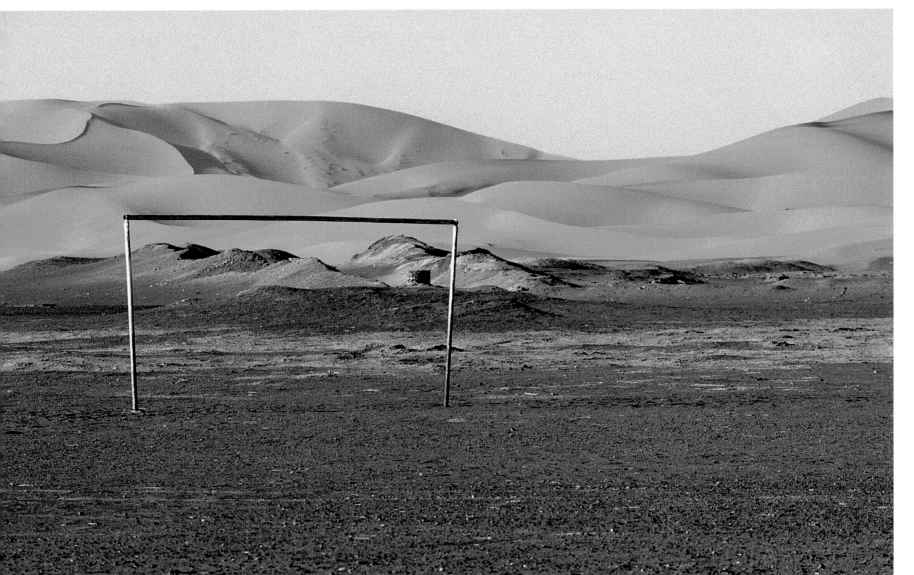

Napoli, Italy

The instructions for setting up an inner-city pitch are simple. Basically all you need are 1. an open space, 2. a can of paint and, ideally, 3. a few pieces of cardboard that happen to be lying around. That's it, now you can get on with the game.

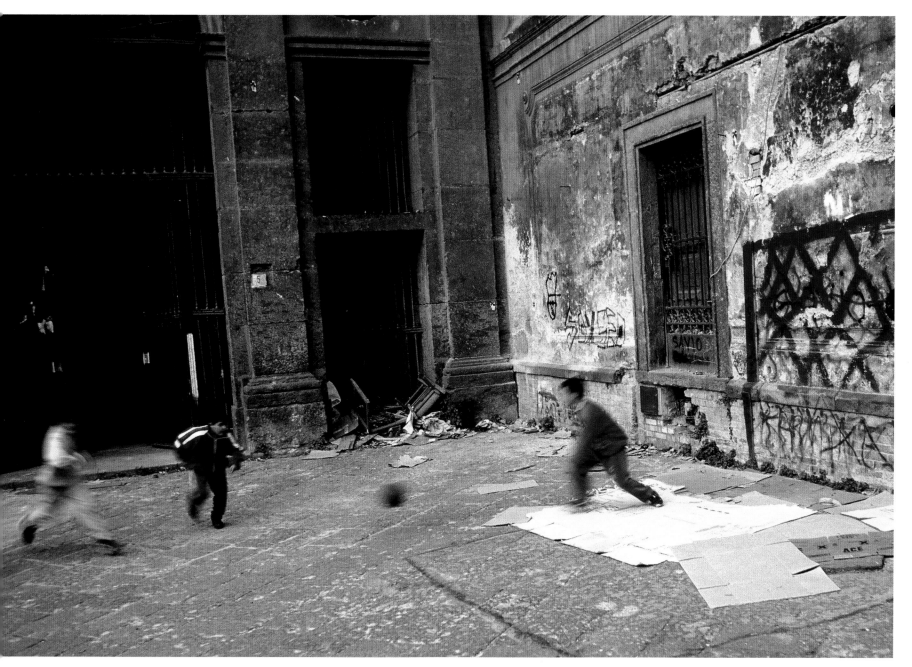

Santorini, Greece

When spring carpets the ground with colourful flowers anyone who goes to retrieve the ball from behind the goal will be tempted to sit down and start playing 'She loves me, she loves me not'.

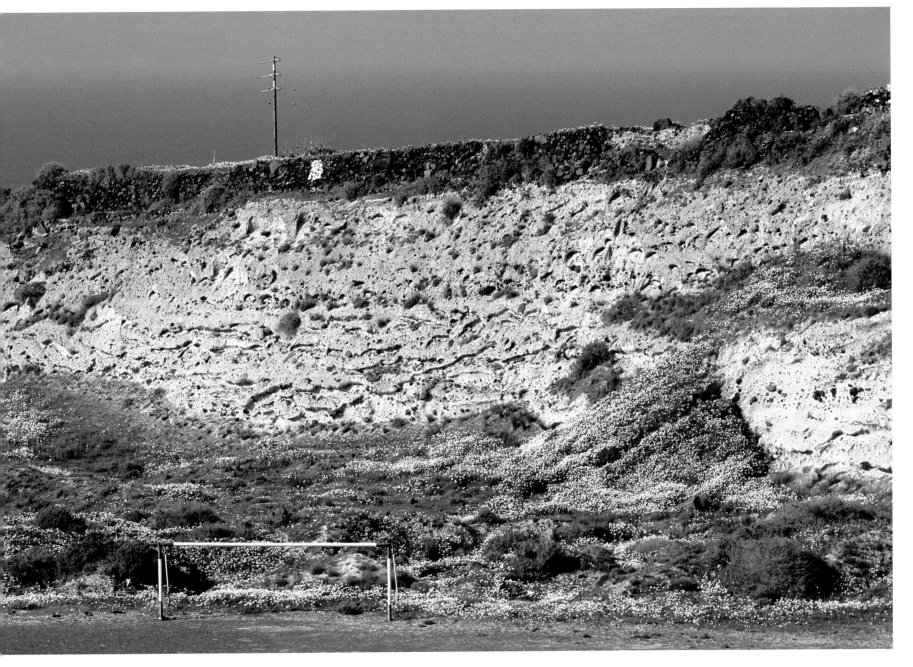

Buenos Aires, Argentina

The boy may be small as yet, but his father has already infected him with the virus and he knows that the time will come when he will step across the gravel path and get involved in the real game. In a city with sixteen professional football teams no one can remain immune to the lure of football.

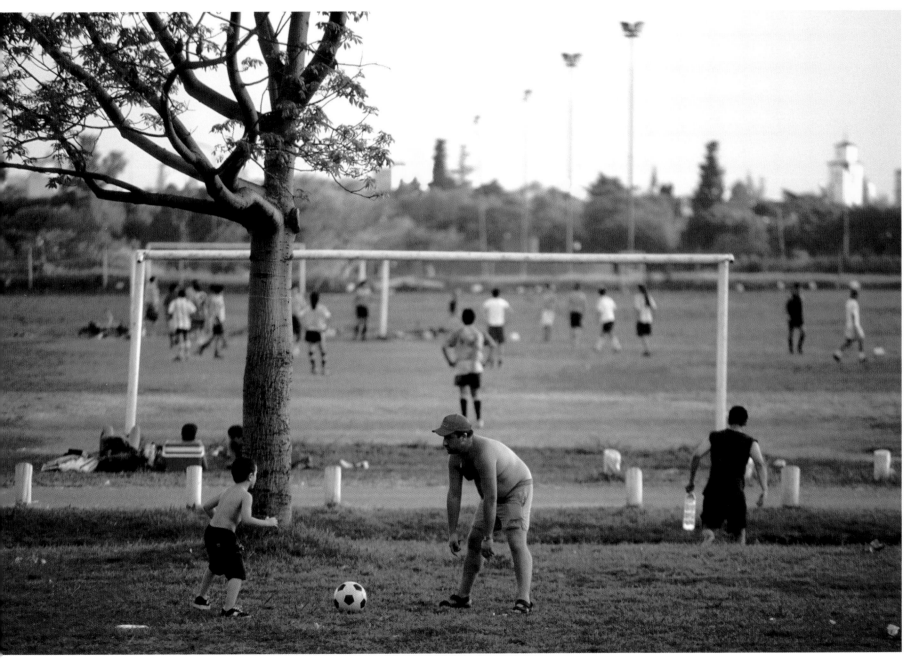

Rio de Janeiro, Brazil

At the foot of Corcovado and its statue of Christ the Redeemer which towers over the city, its lake and the sea beyond, a green-baise pitch awaits the magicians who will show off their conjuring tricks with the ball.

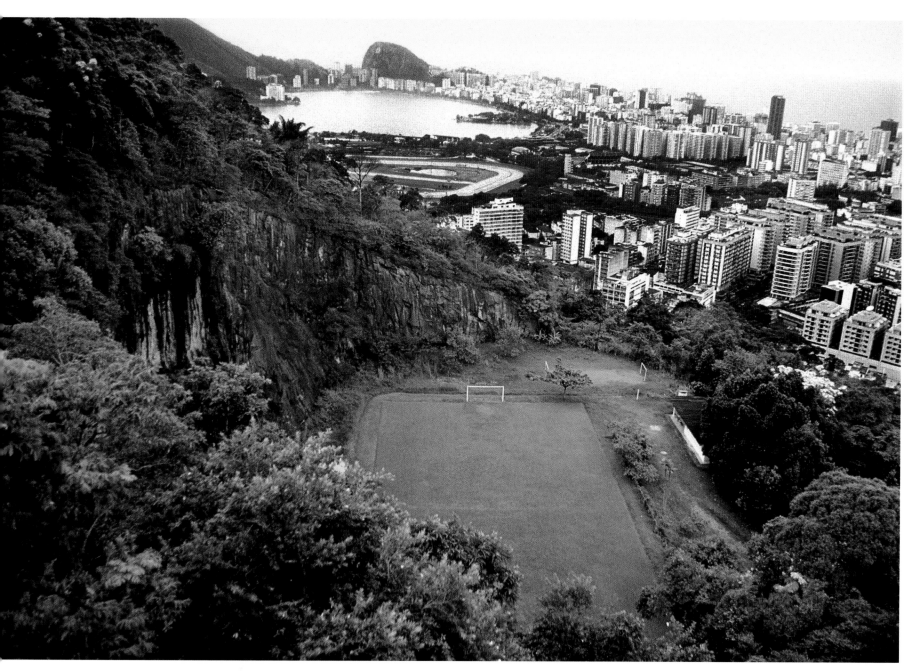

Pahoa, Hawaii, United States

There's always someone bent on defying the laws of nature by trying, for example, to control a ball without flexing his knees.

Following pages (left and right):

Buenos Aires, Argentina

Not long ago the unevenness of the cobbled streets provided the first challenge for a budding football star. These days, the local authorities have smoothed the road to fame a little.

Passos, Vila-Real, Portugal

Poised to make the feint. Which foot will strike up the baseline with the ball? Which will play the counterpoint of the feint?

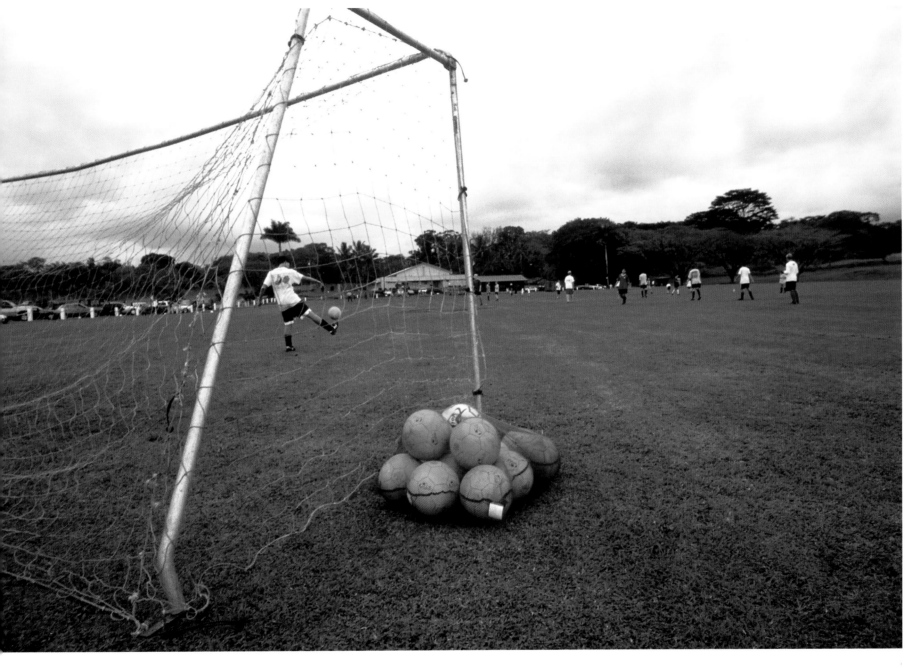

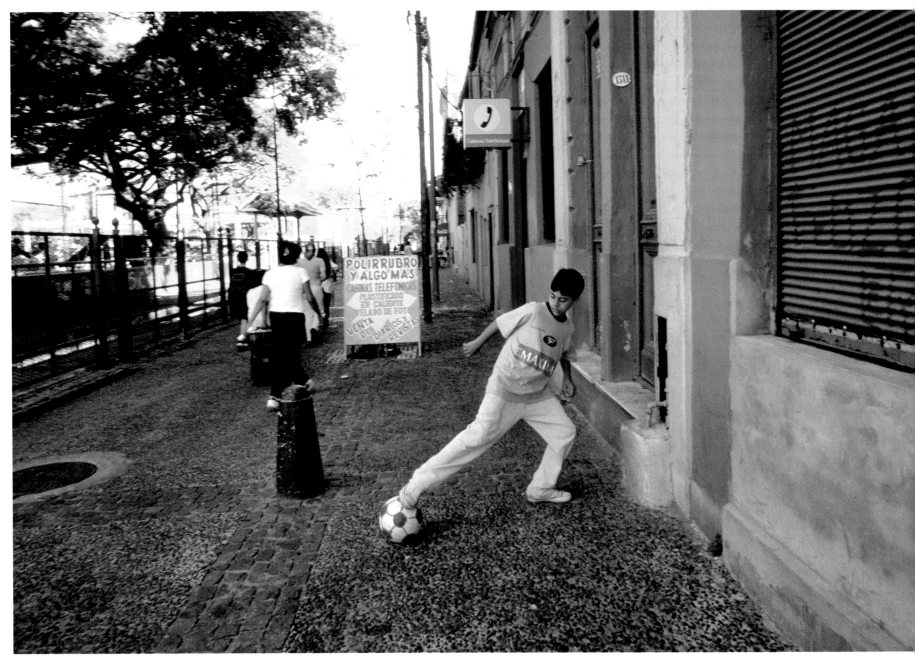

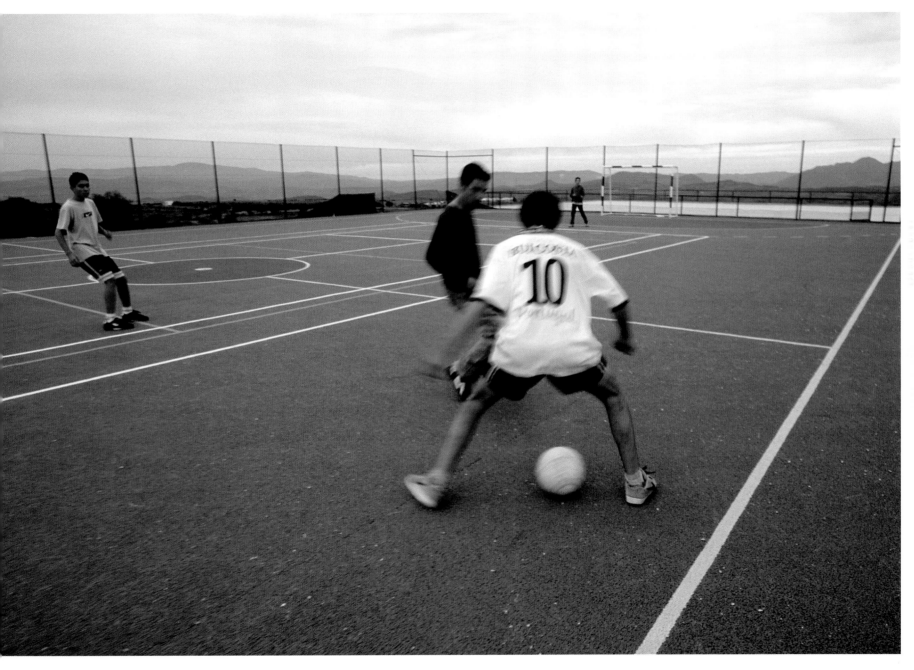

London, England

Typical winter weather in London, and a man with his bike and dog crosses a flooded pitch beside the River Thames. The birds perched on the crossbar, like the neighbourhood footballers, seem resigned to waiting for better times.

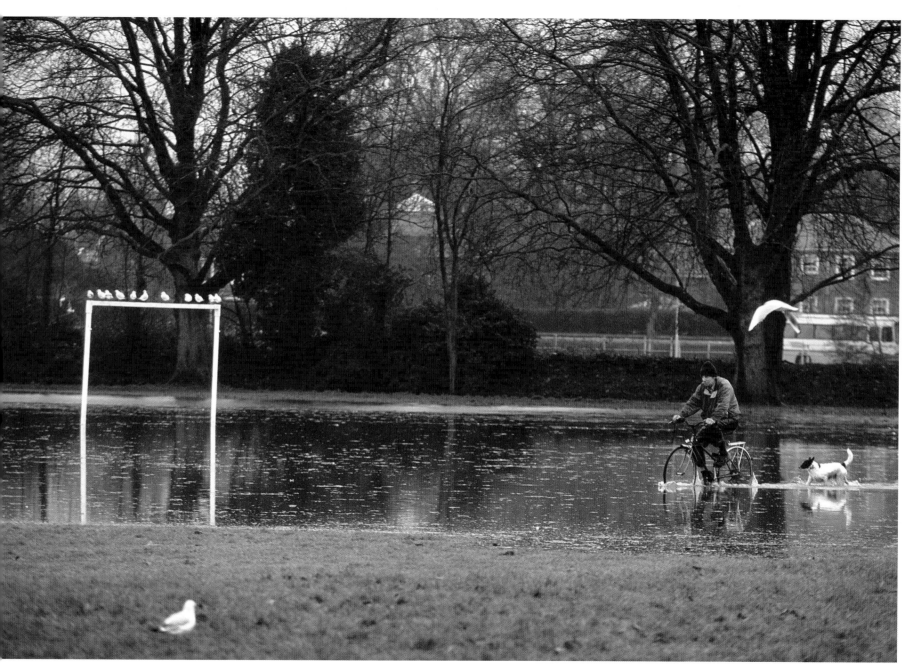

Antaquilla, Ulla Ulla, Bolivia

At an altitude of nearly 4,000 metres oxygen is scarce, but that doesn't deter the women of the village from taking over the football pitch. The men are the VIP audience at this spectacle of whirling skirts, petticoats and shawls.

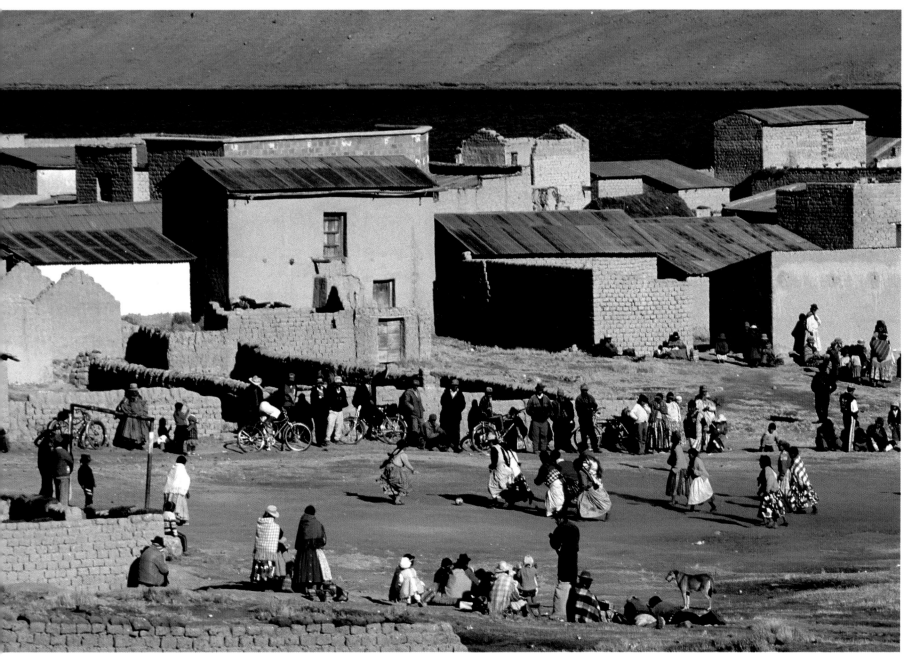

Nicolosi, Sicily, Italy

Just as it says in the textbooks, you have to thrust your shoulders forward and hollow your chest so that the ball rolls down and falls at your feet.
The church door is about to be rattled by a cannon-ball shot.

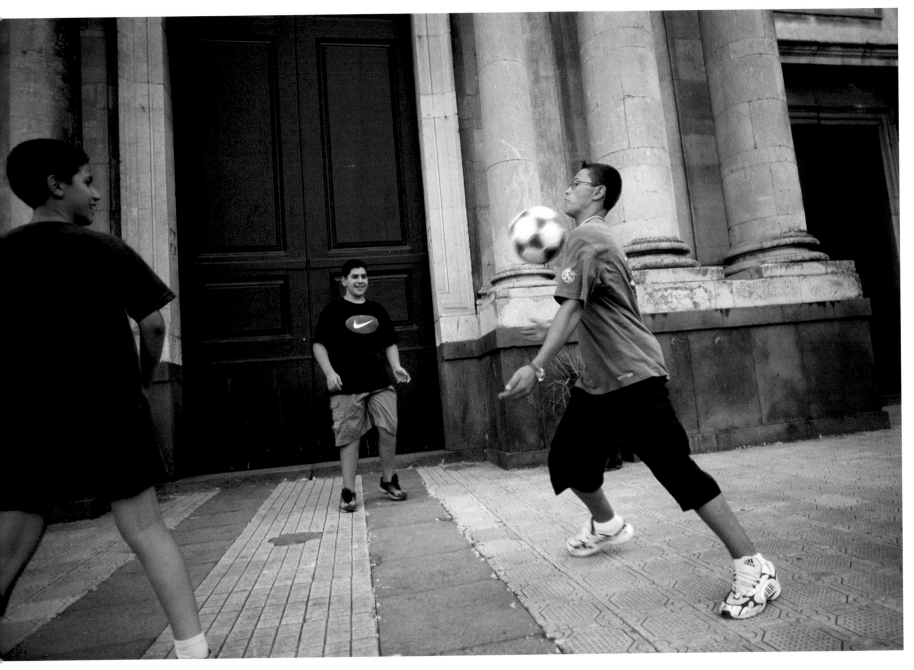

Maun, Botswana

Bare feet and a ball made of a plastic-wrapped stone secured by old shoelaces are the order of the day here, where the goal is as wide as the street.

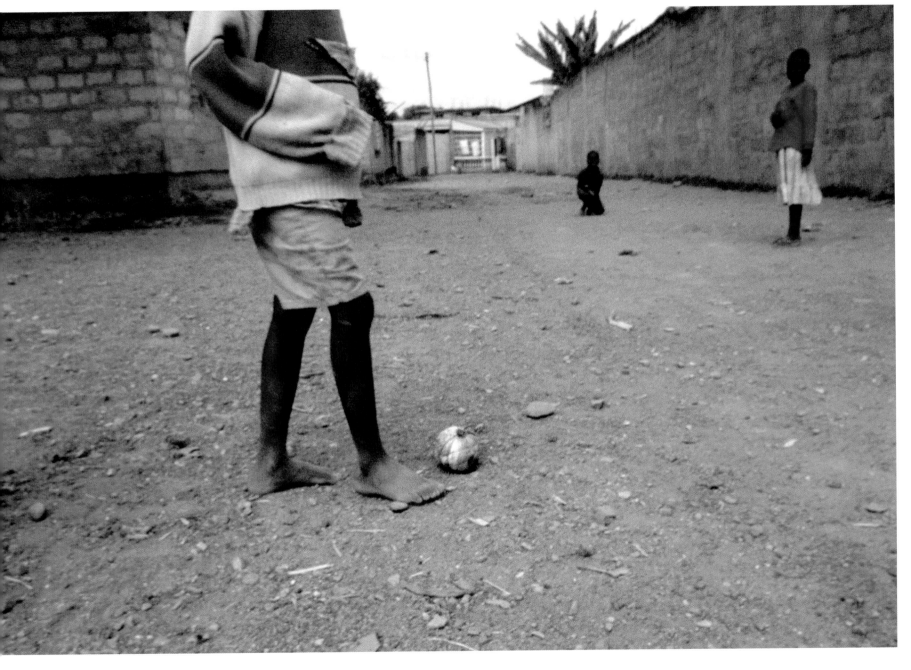

Castellar de N'Hug, Catalonia, Spain

There have always been witches in the Pedraforca Pyrenees where their winter spells call a halt to football as the pitches stand frozen to iron beneath the snow.

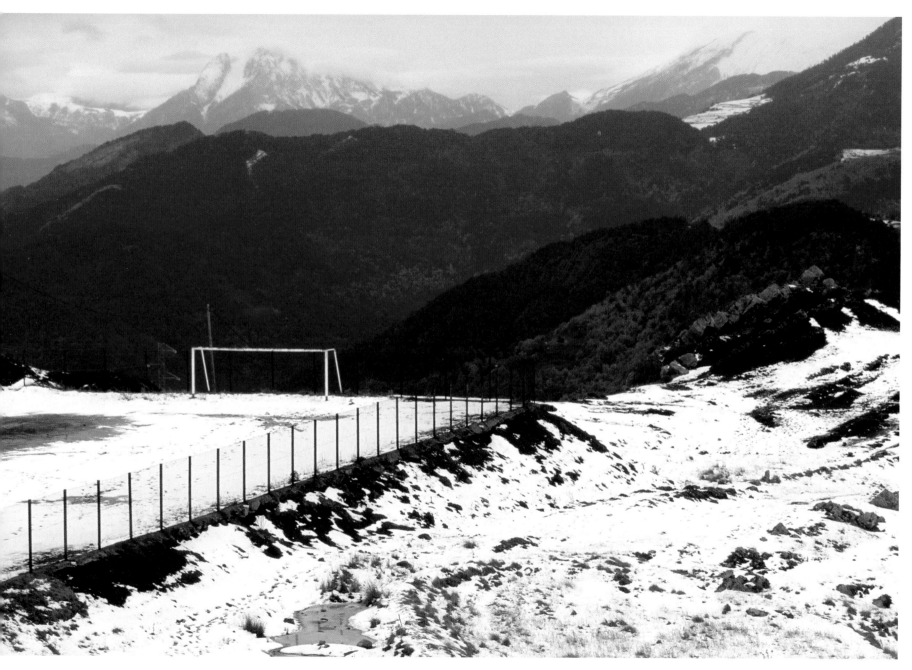

Isla Gran Roque, Los Roques, Venezuela

The ball is coral-coloured like the nearby reef and the goal is as minuscule as the island itself. So all is in proportion on this Caribbean archipelago, where it is easier than usual for the goalkeeper to make a save.

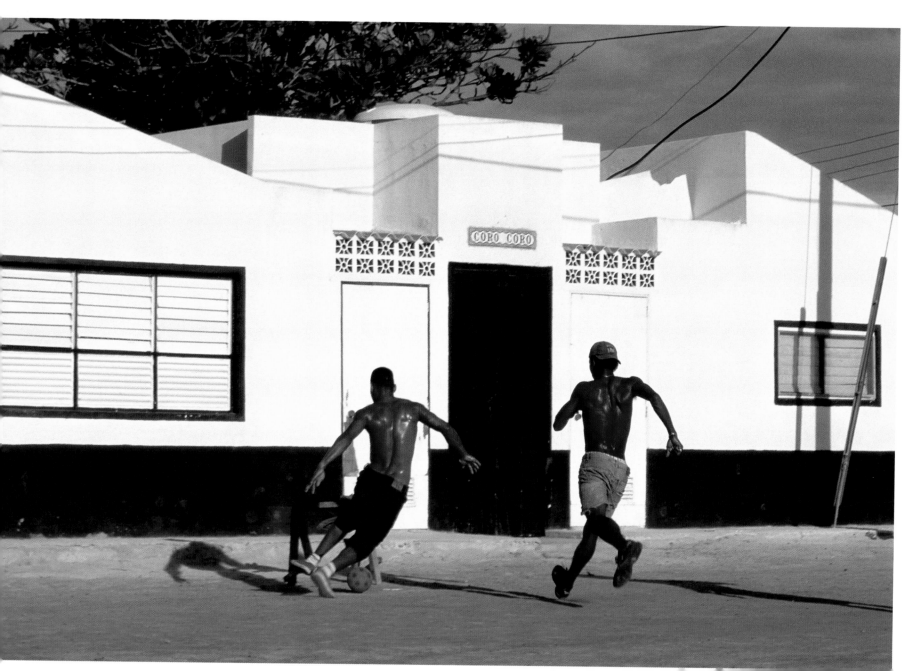

Corozal, Islas de la Bahia, Honduras

Which came first, the goalposts or the shed? Either way the goalkeeper will have his back well protected.

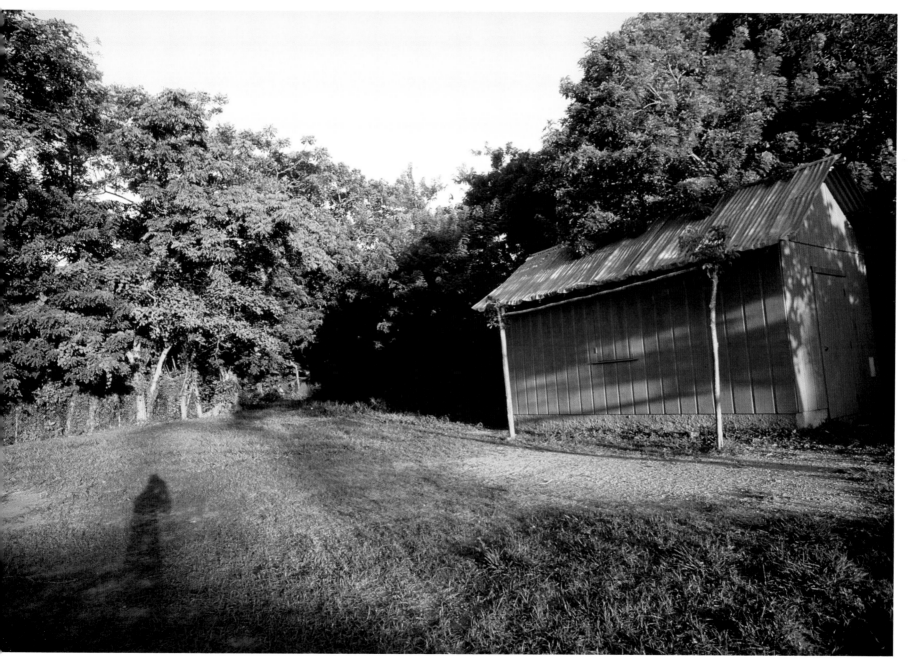

Boa Vista, Sao Tome and Principe

In Africa's smallest country, 47% of the population is under fourteen. It therefore comes as no surprise that budding footballers are to be found everywhere, even on the terraces where the coffee is laid out to dry after the harvest.

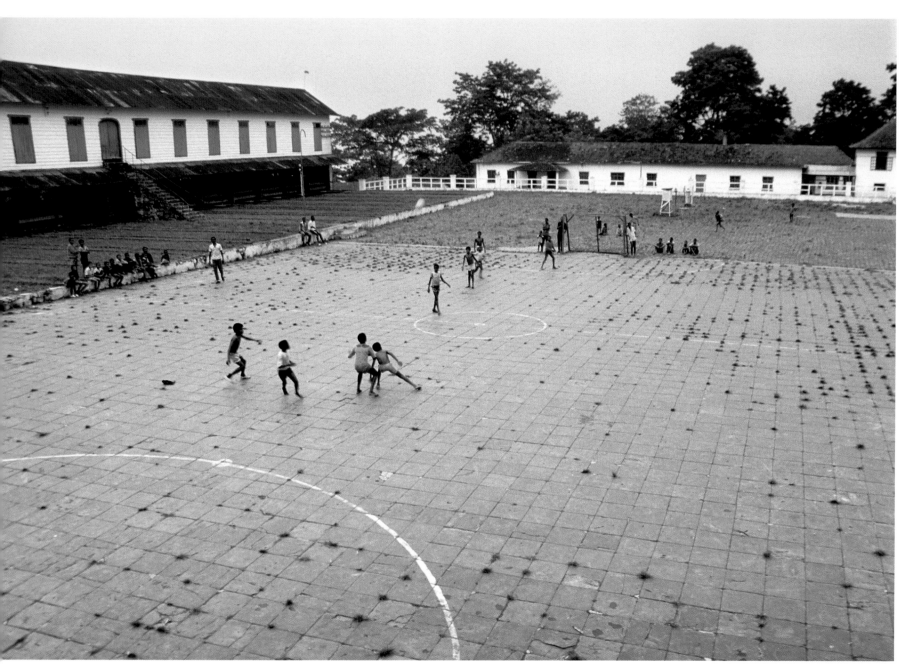

Tahiti, French Polynesia

The lushness of a tropical forest is all around, but nothing distracts this young man from mastering the dialogue between head and ball.

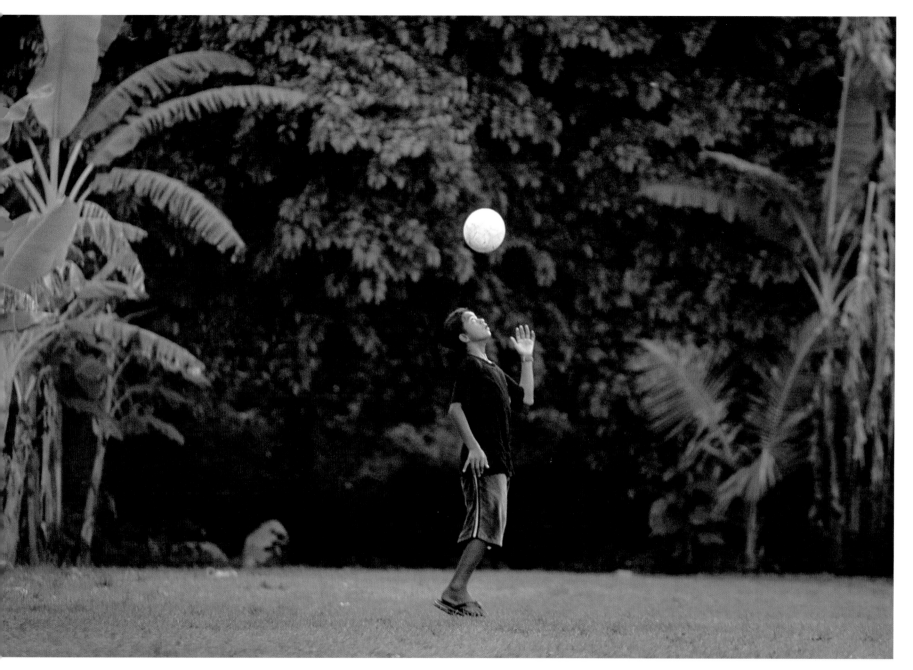

Sabroso de Aguiar, Portugal

Towels and shirts used by the players in the last game soon dry out in the sun. How long will it be before the next game begins?

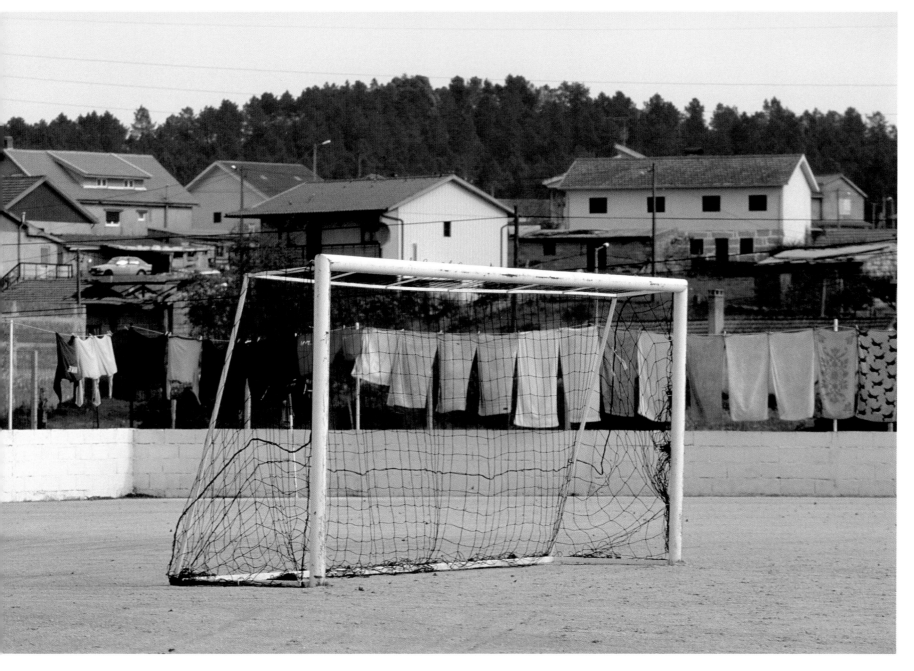

San Pedro de Atacama, Chile

When shooting with the inside of the foot, placement is more important than brute strength. Too hard a kick might awaken the desert gods who are resting 5,916 metres up, at the summit of the Licancabur volcano.

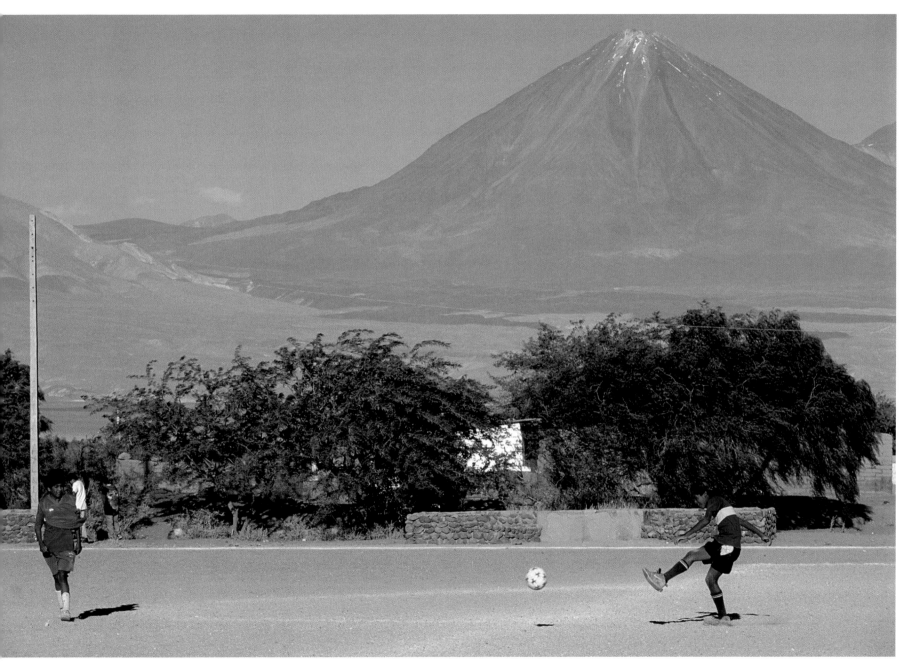

Villa Palmira, Uruguay

The trees and weeds may swallow up the goalposts but they cannot uproot them.

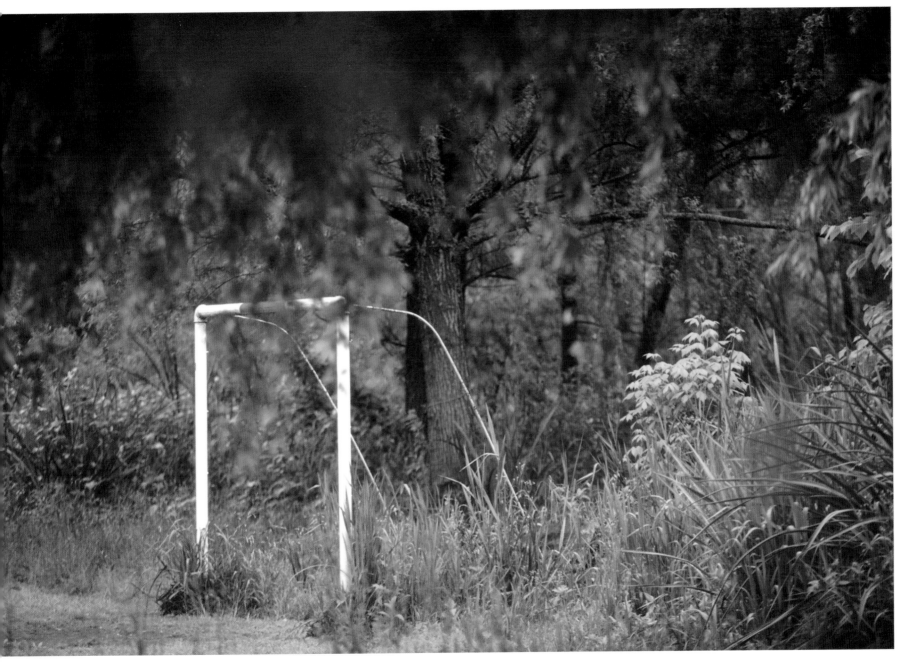

Kyoto, Japan

Japanese tradition embraces many sports: sumo, martial arts, even baseball. But it is only football that can put a smile on the faces of these schoolboys.

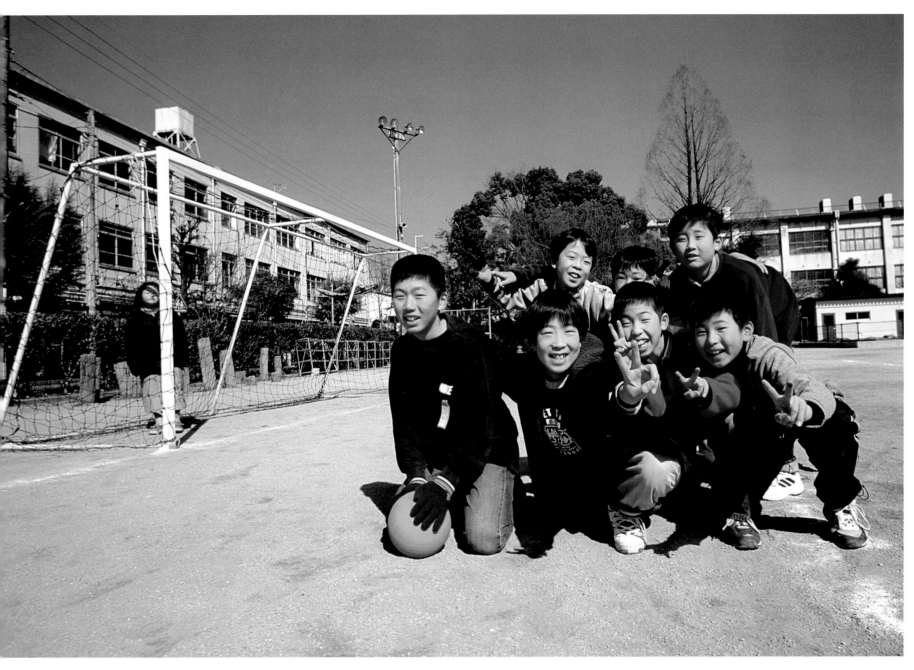

Santorini, Greece

Locals say that the sound of the sea charms and hypnotises visiting goalkeepers, so that they become incapable of stopping even the weakest of shots. This rumour probably owes more to optimism than experience.

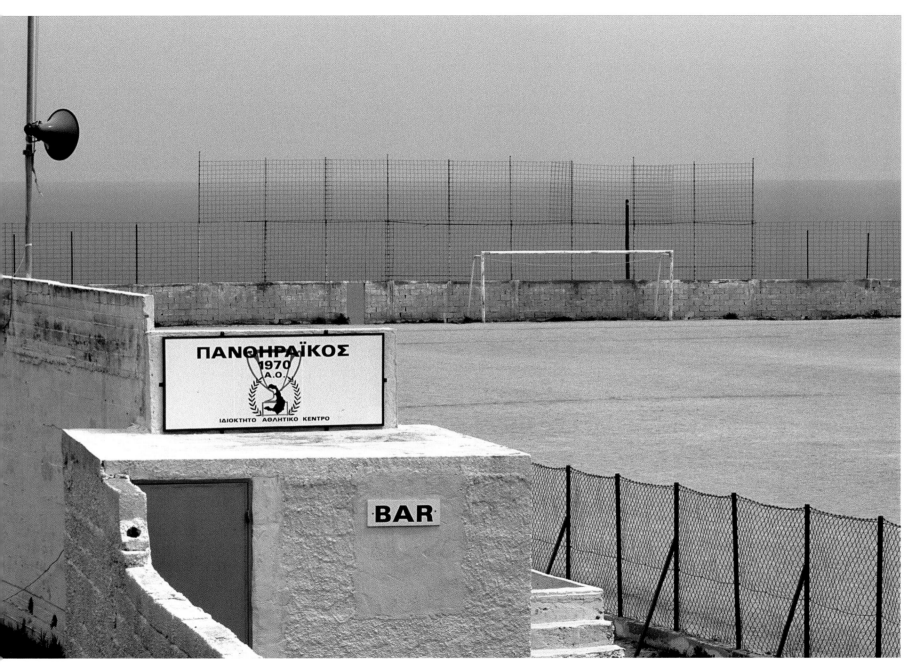

Serengeti National Park, Tanzania

Their striped kit distinguishes the zebra team, one of the biggest names in the annual Serengeti championship.

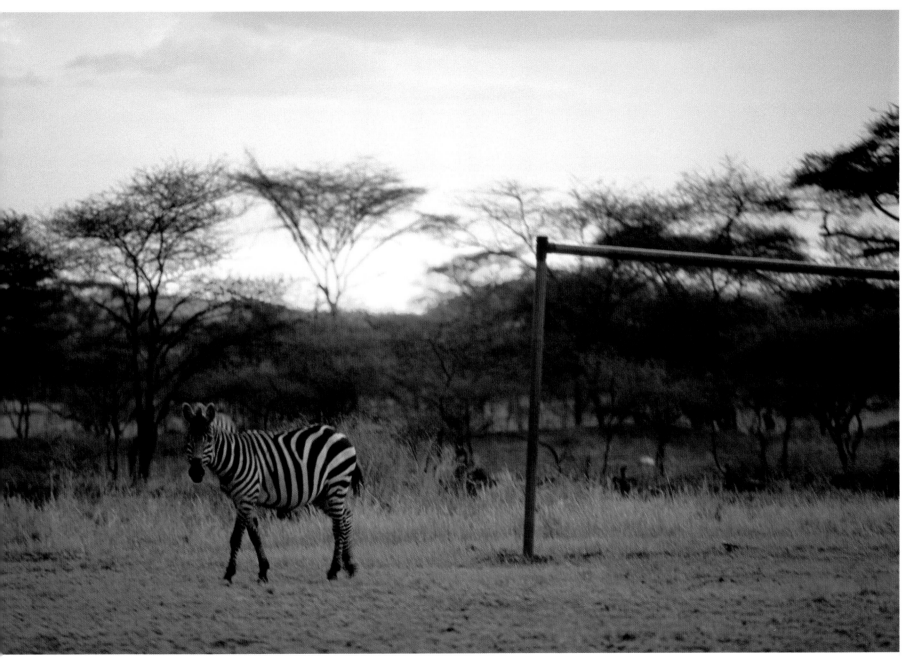

La Paz, Bolivia

This neighbourhood, aptly called 'The Heights', connects La Paz's airport with the city. Here, at 4,080 metres above sea level, even running after a ball becomes a feat of heroism.

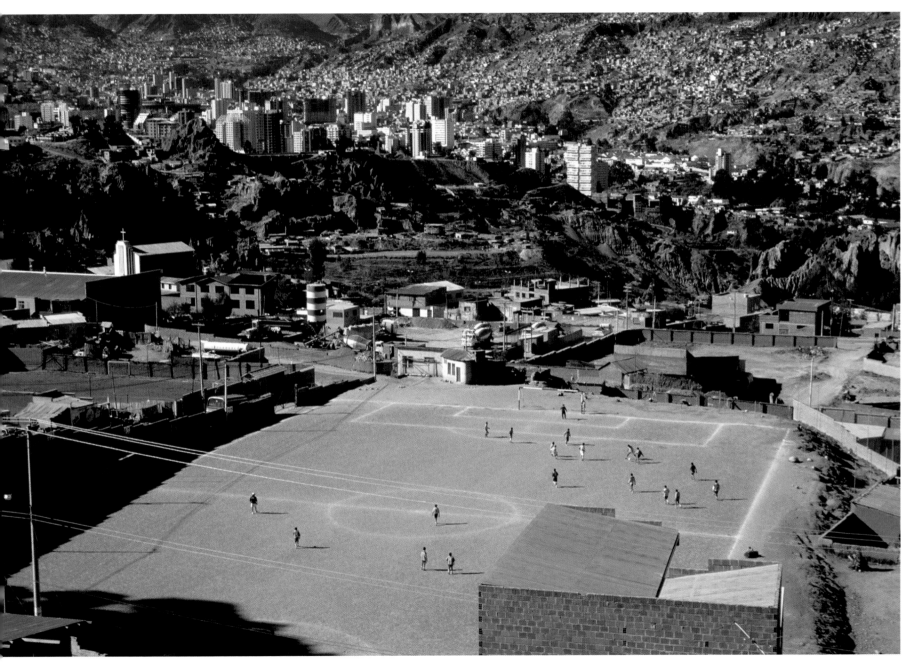

Big Island, Hawaii

Hawaii is the only place in the world where football has become more firmly established among the women than the men. Here it is the girls who stylishly and gracefully master the laws of the cutback and the shot; while the men shuffle clumsily by.

Following pages (left and right):

London, England

The grass tries to peg the water back in its penalty area, but the floodwaters are mounting a counterattack down the wing with just a few birds looking on.

Atlas Mountains, Morocco

The terraces are a wasteland; it's impossible to predict which way a ball will bounce and the goalposts are Lilliput-sized. Anyone who scores on this pitch will have advanced several steps along the road to redemption.

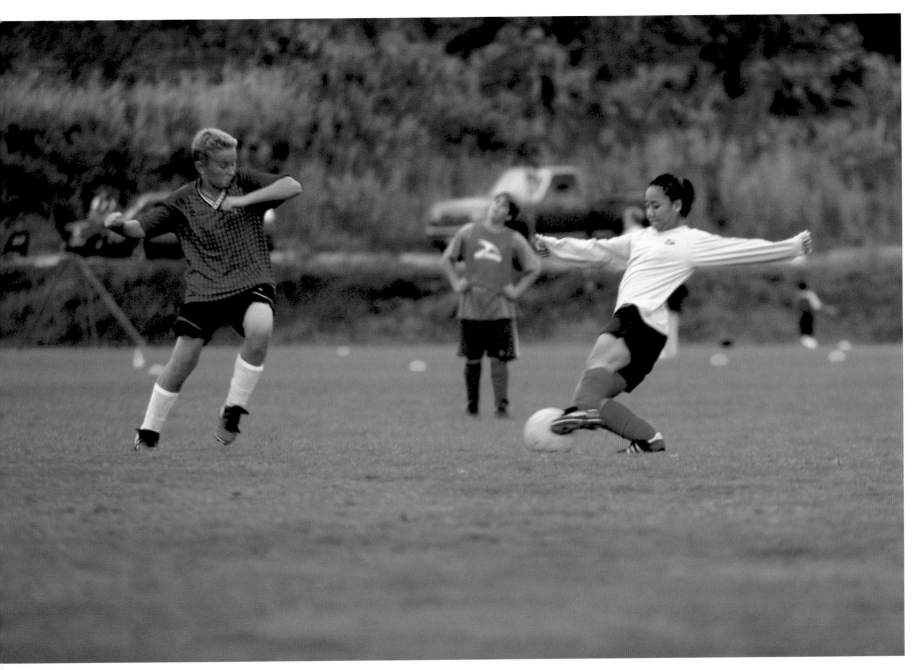

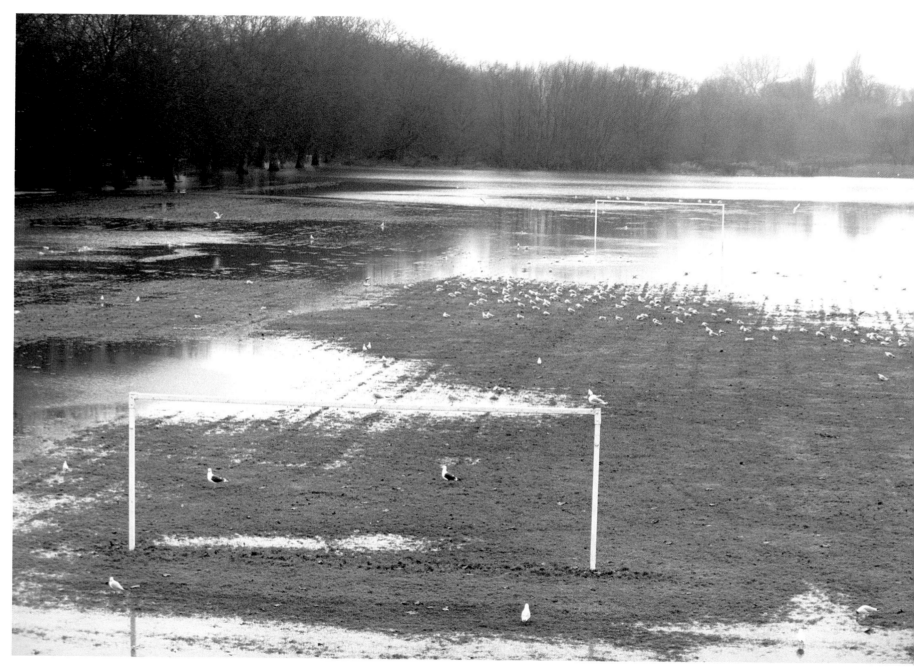

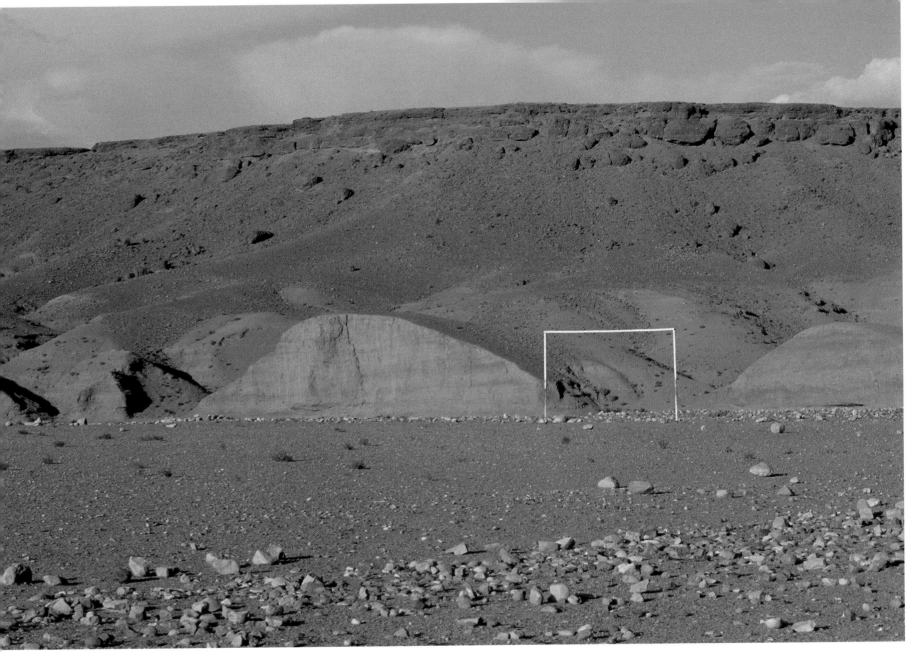

West Bay, Roatán, Honduras

One touch, two, three. Tick, tock, tick, tock. You have to keep the ball up in the air, you can't allow even a single grain of white fine sand to sully its surface. Even the clear Caribbean waters come up close to admire this improvised exhibition of skills.

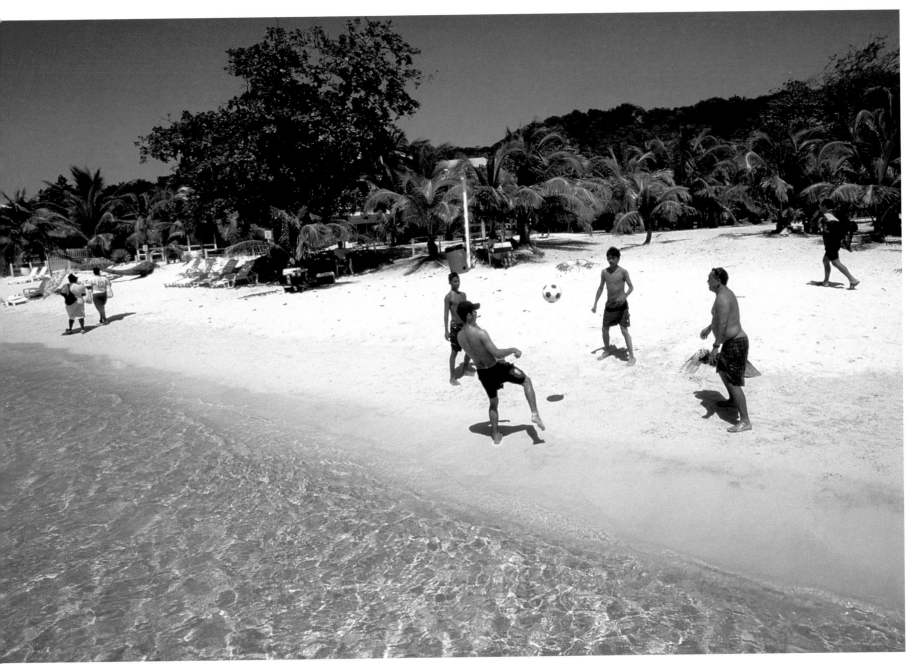

Moorea Island, French Polynesia

Who knows why, but there's no football this afternoon. Propped up on their surviving support, the goalposts frame a picture that might have been painted by Gauguin.

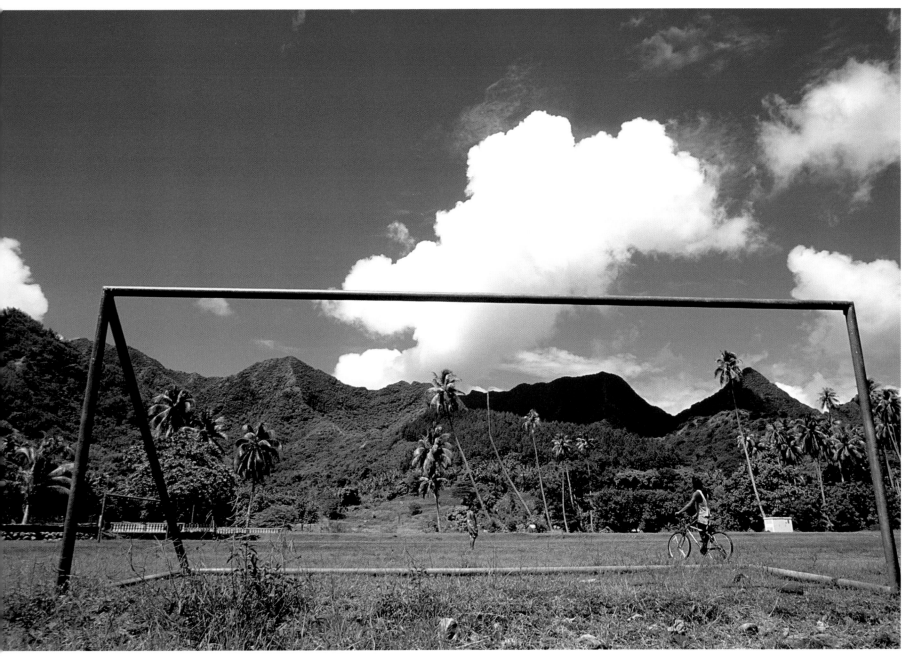

Chitimba, Malawi

While a fisherman tries his luck in the middle of the lake and the goats patrol the beach in search of food, the boy's attention is totally focused on his solo game.

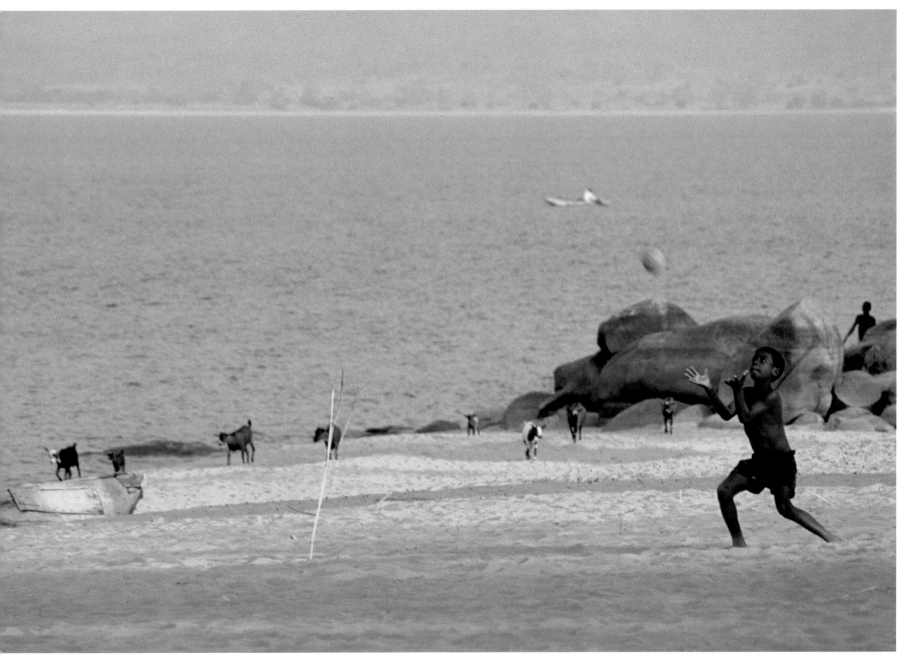

Villa Paranacito, Argentina

The storm has passed and life in the delta of the River Paraná slowly returns to normal. The washing will dry out quickly enough but it will be a few days before anyone can play football.

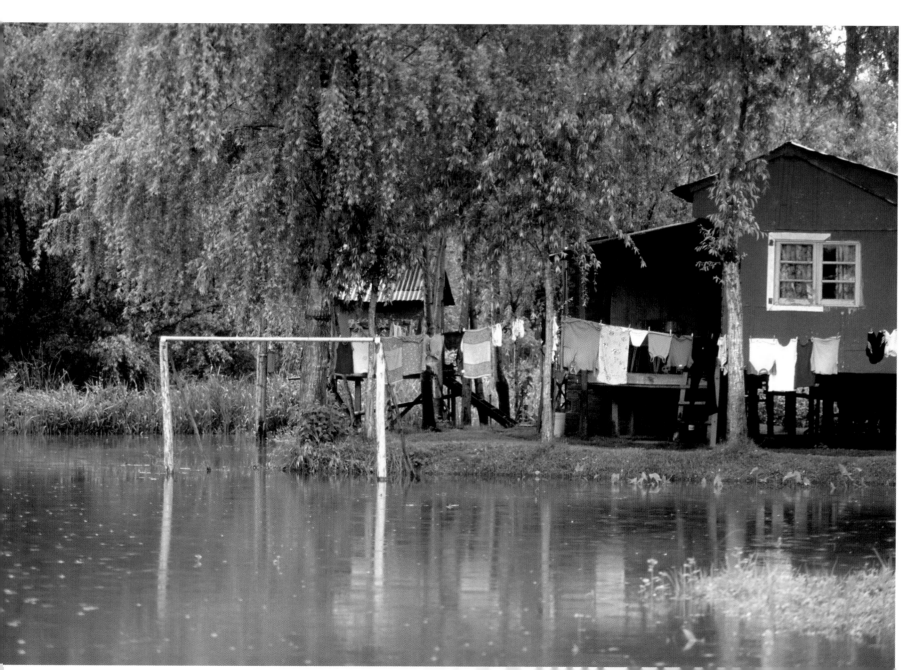

Barcelona, Spain

Even when football is squeezed into school playgrounds with concrete floors and surrounded by glass, aluminium and neon, it continues to engage the emotions as strongly as ever.

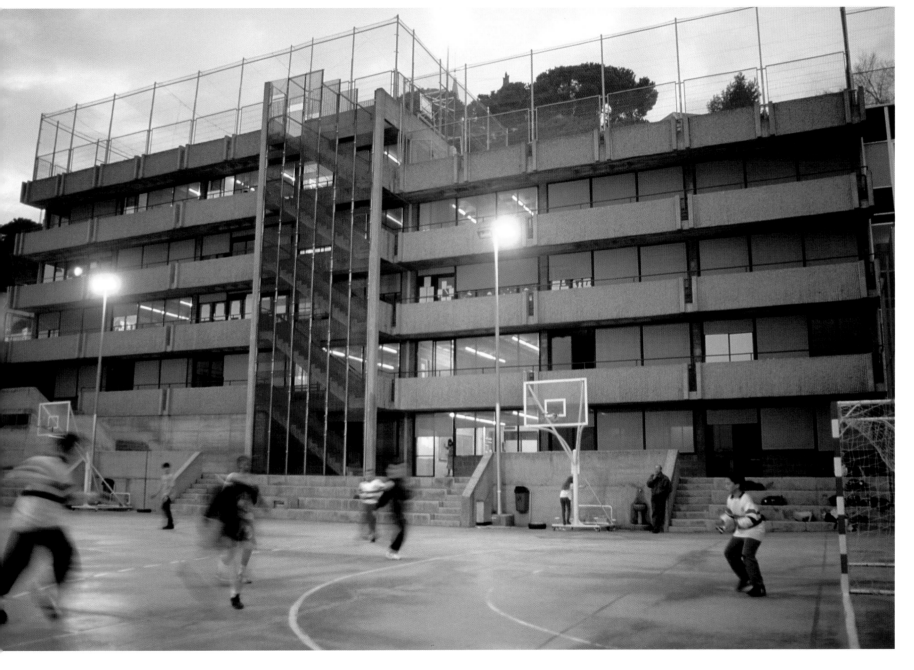

Richmond, London, England

The crossbar makes a convenient observation point for a lone crow in search of food on a grey winter's day.

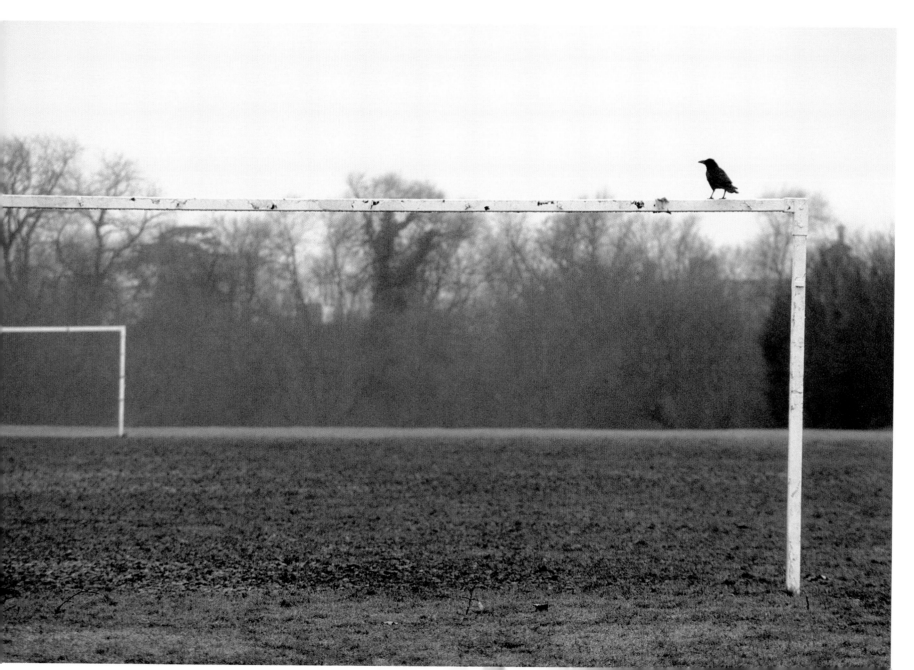

Capadocia, Turkey

History is written on every stone in this ancient land, but the young boy coming down the steps is clearly dreaming of his footballing future.

Following pages (left and right):

Tras-os-Montes, Portugal

A harsh climate has taken its toll on the rusted posts but the net has also had to contend with the efforts of some energetic strikers.

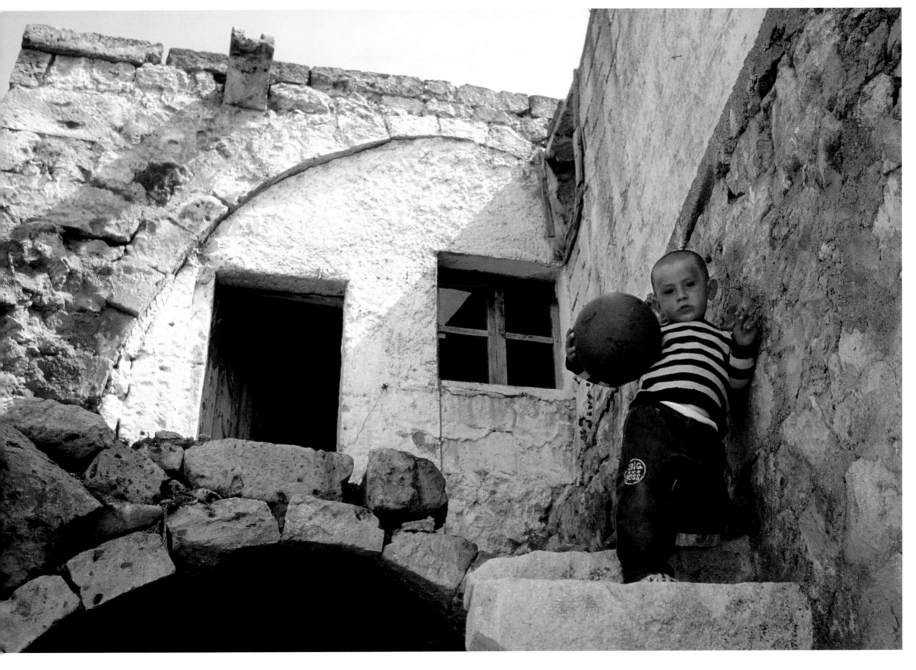

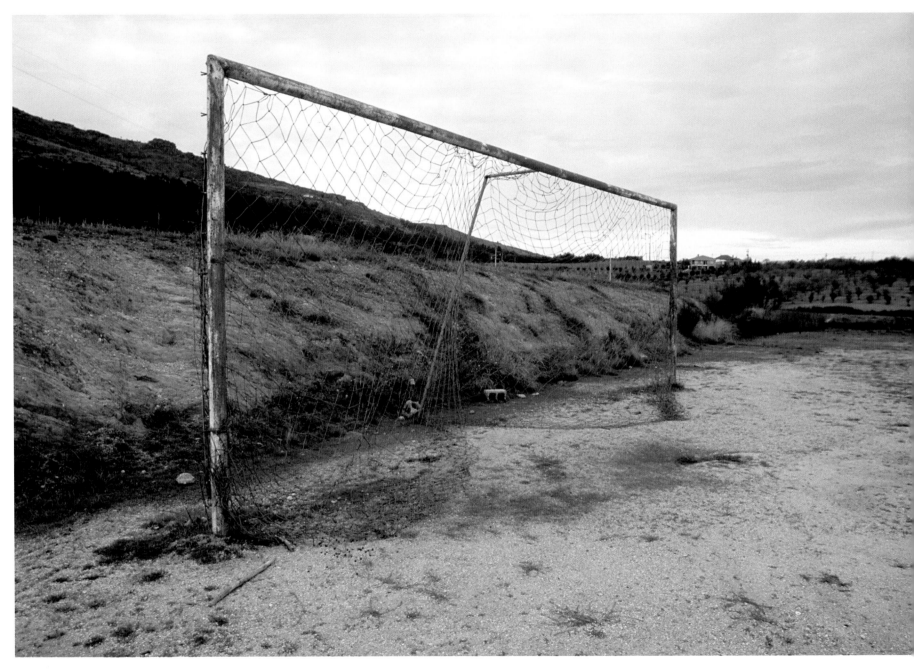

Loreto, Peru

A goal produces, simultaneously, instant euphoria and infinite sorrow, inner satisfaction and suppressed rage. But on the banks of the Amazon it can also involve taking a dip to fish the ball out of the world's mightiest river.

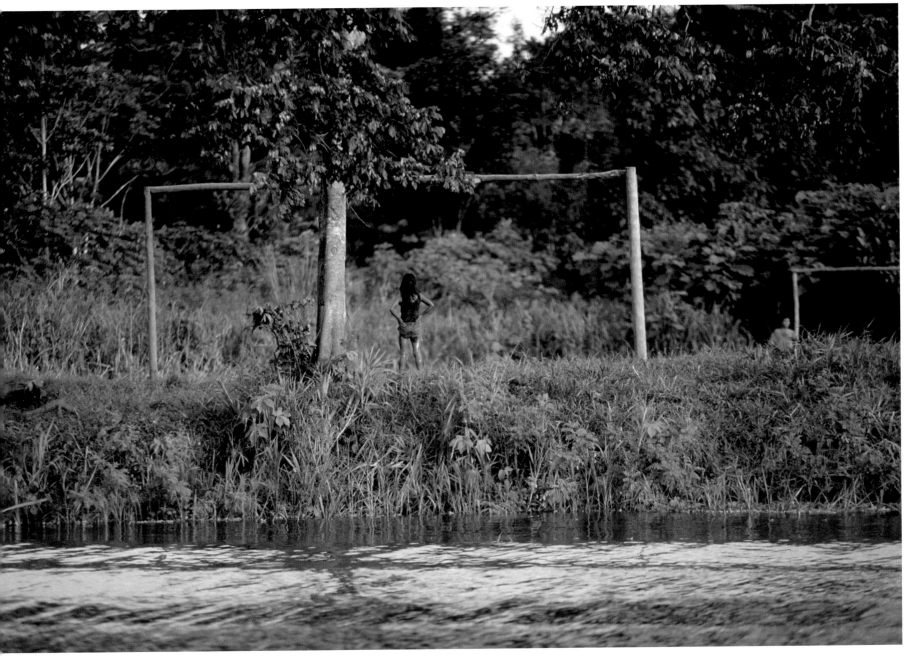

Nyika, Malawi

Thorny bushes, parched earth, barefoot children, stones that serve as goalposts.
Even a kick-about can be a test of fitness for survival deep in impoverished Africa.

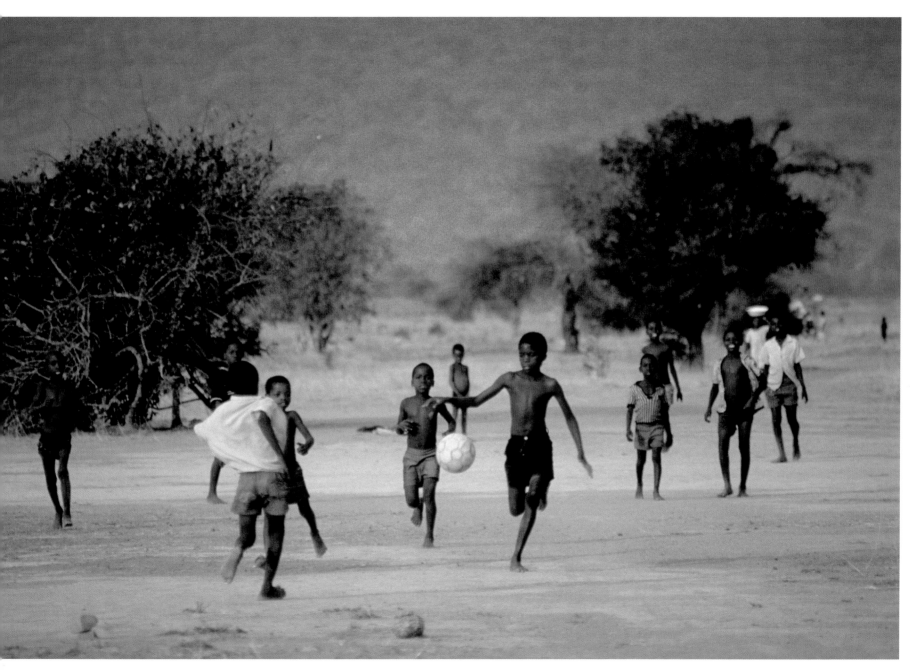

Nagano, Japan

The snow, a frequent visitor to the Japanese Alps, has just laid a white cloak over the pitch.

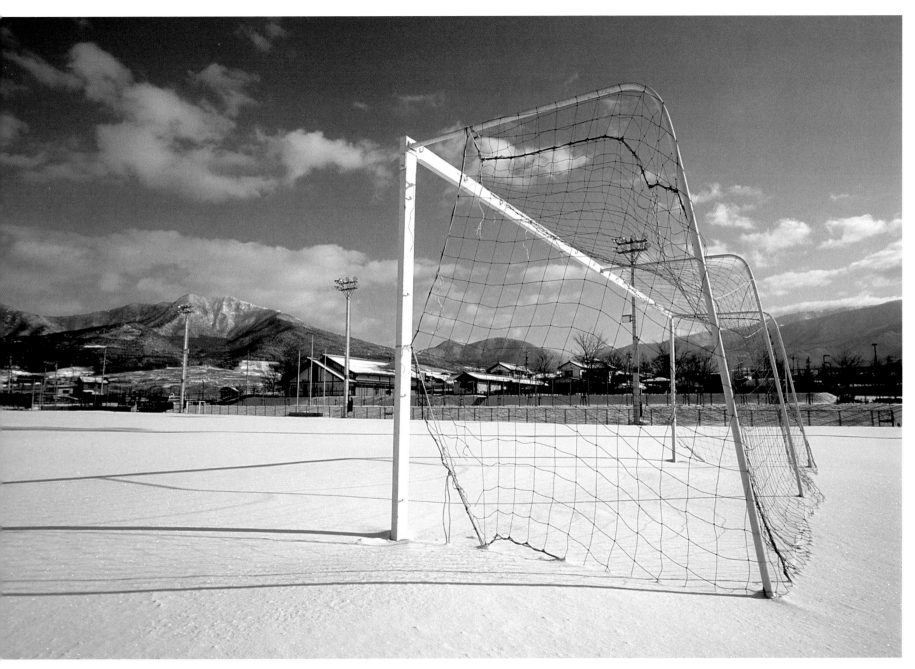

Villa Amarka, Ulla Ulla, Bolivia

Dust clouds the atmosphere and makes it hard to breathe. But neither the elements nor poverty can put a dampener on a classic match.

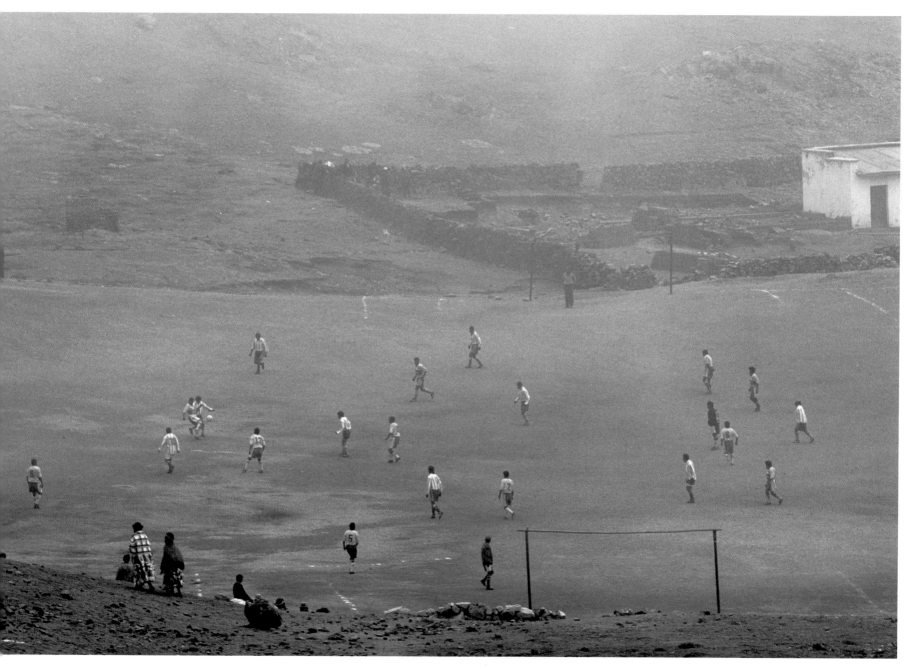

Buenos Aires, Argentina

When you are born among the brightly painted houses of the La Boca neighbourhood, football is something you simply have to get the hang of. So it's a good idea to start as early as possible.

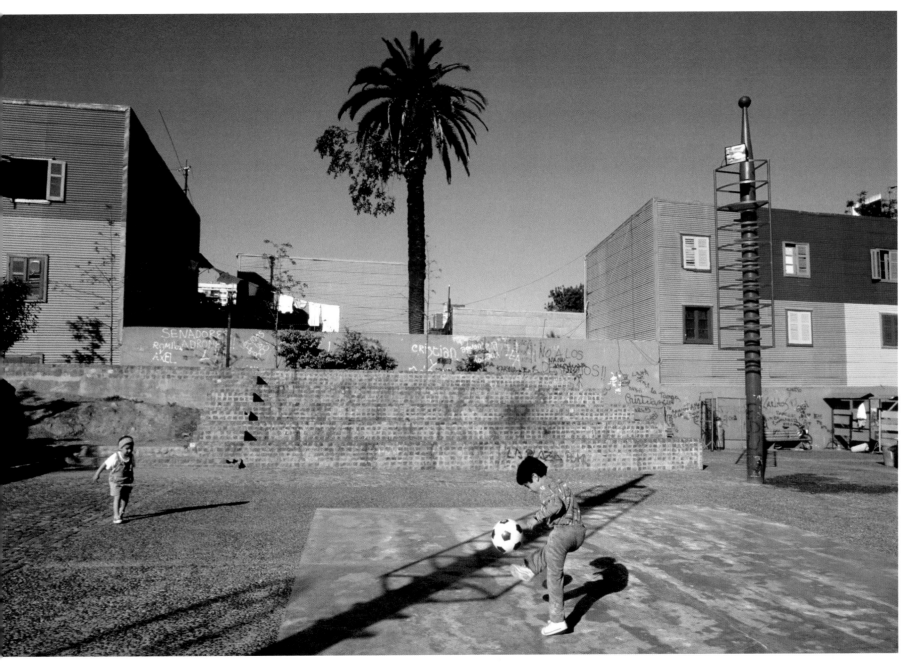

Serima, Zimbabwe

The donkey seems totally unmoved to find himself just yards away from an open goal.

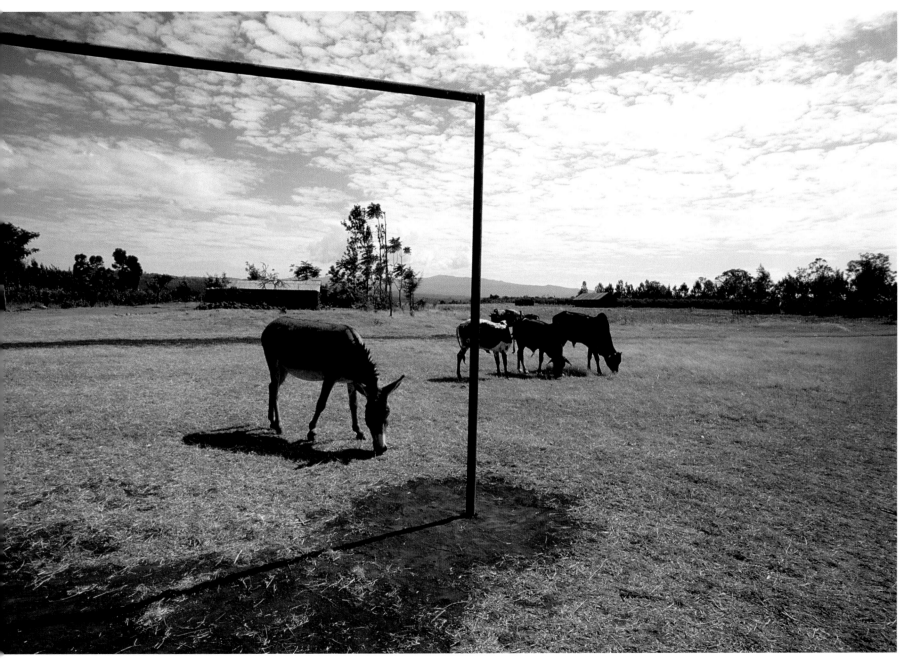

Buenos Aires, Argentina

You can sometimes spot a person's vocation in life at a very early age. There are kids like this one who decide, one fine day, to split off from the rest of the pack and take their stand between two white posts. From that moment on that will be their home until age or infirmity removes them.

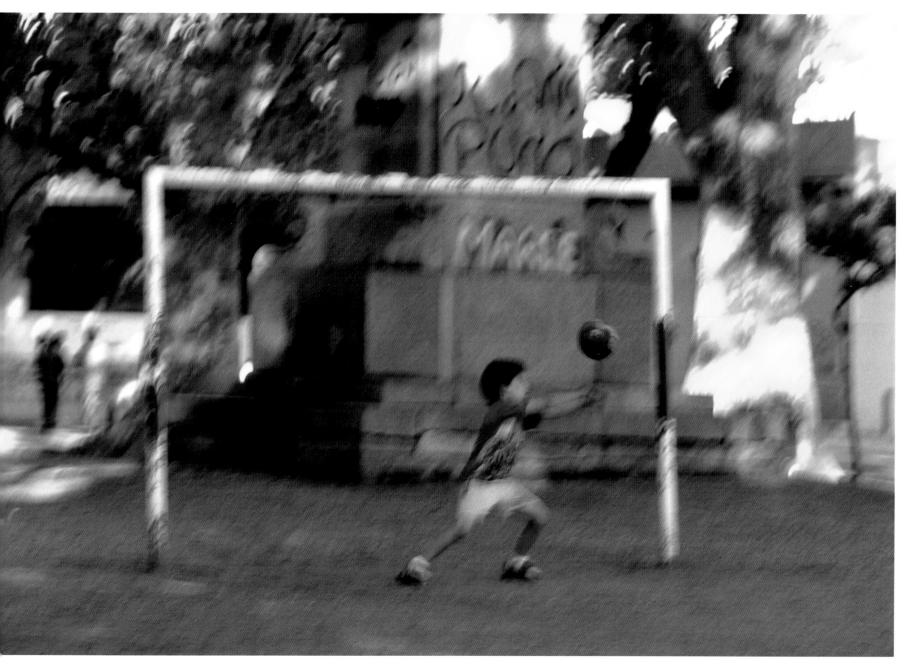

Usa River, Tanzania

The prospect of the match about to start doesn't leave room for any distractions. Even when the imposing bulk of Kilimanjaro soars to 5,895 metres on the skyline.

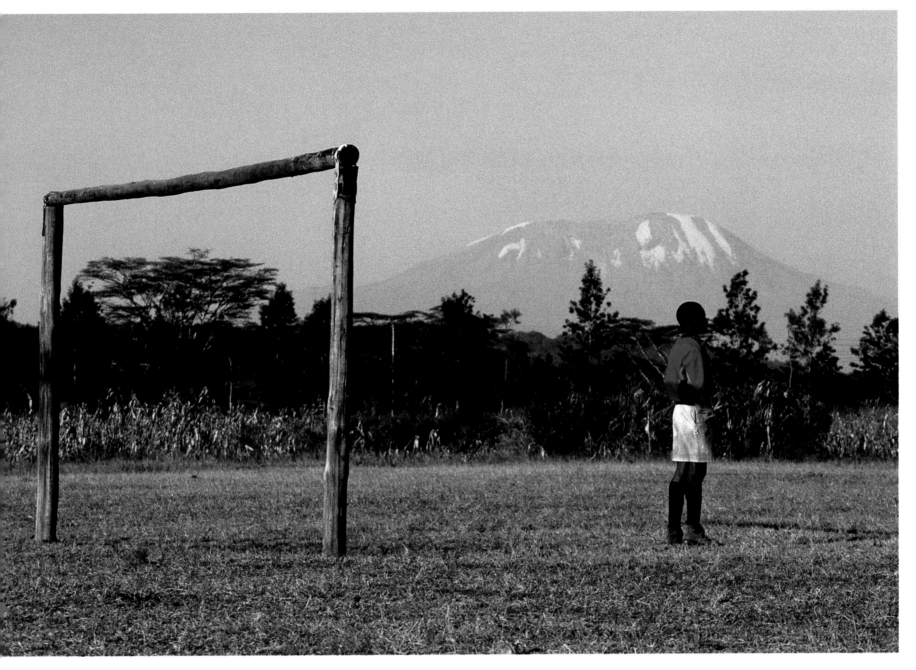

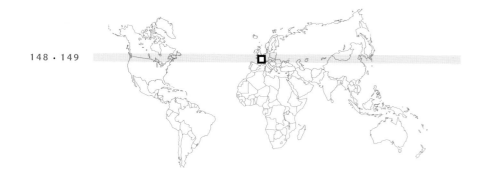

Vendras, France

The construction of the goal is not very orthodox and the grass could do with a mow, but so what – even in football nothing is perfect.

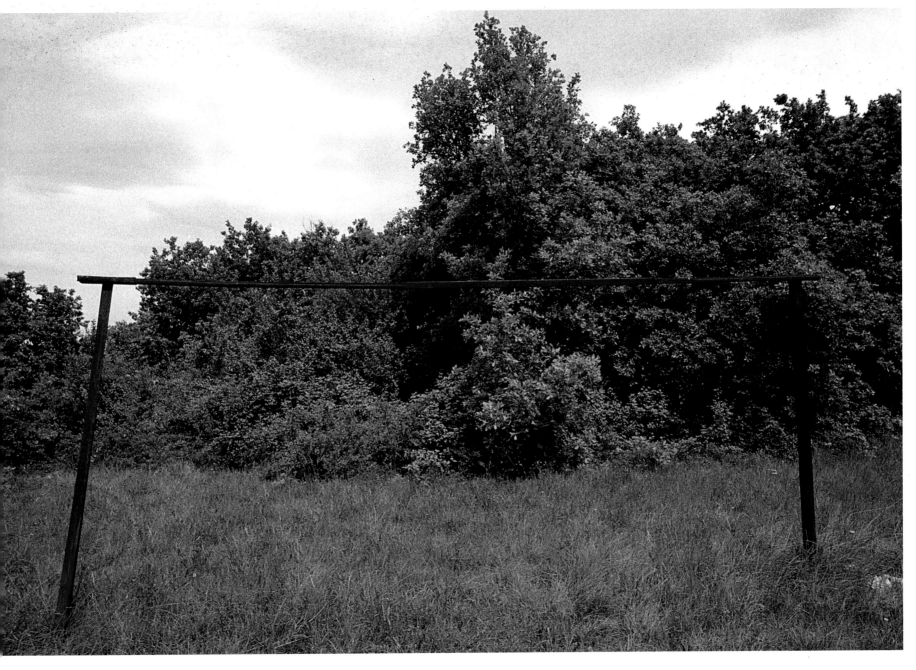

Casalarreina, La Rioja, Spain

In the silence of a deserted pitch you can hear echoes of the shouted orders, insults, imprecations and exultations that have rung out from those two white boxes.

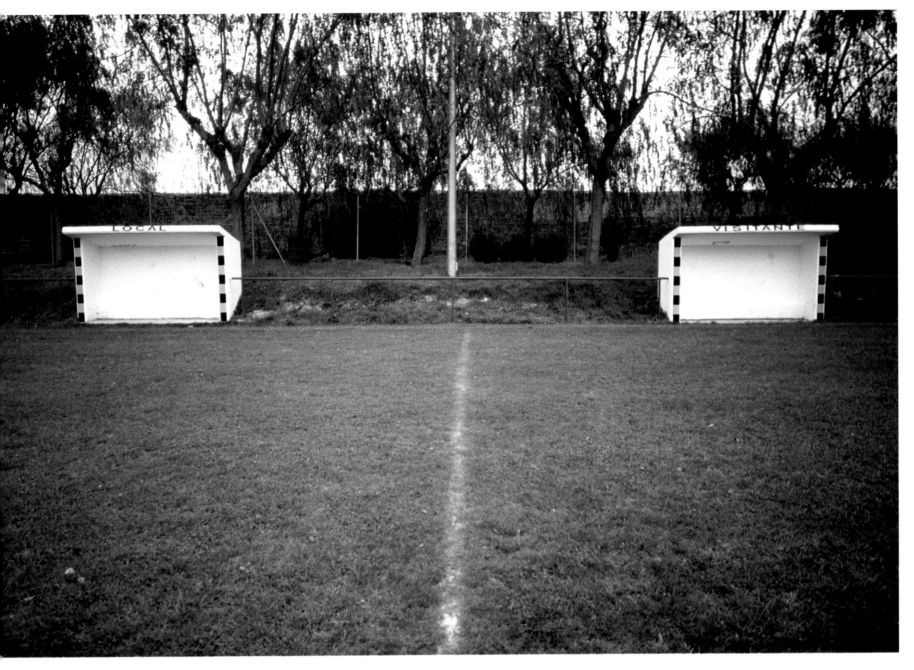

Fira, Santorini, Greece

The immaculate church walls form right angles against the deep blue of the sky. But spiritual matters are far from the minds of the two lads dribbling their ball along the roadway.

Following pages (left and right):

Castellar de N'Hug, Catalonia, Spain

Winter carpets the town in a uniform white. Just the dabs of colour on the goalposts serve as a reminder of a passion that may hibernate, but is unlikely to disappear.

Naraganá, San Blas Islands, Panama

It's getting late, it's raining and dinner is ready in the Kuna Indians' heartland. But the match can't end until the deciding goal is scored.

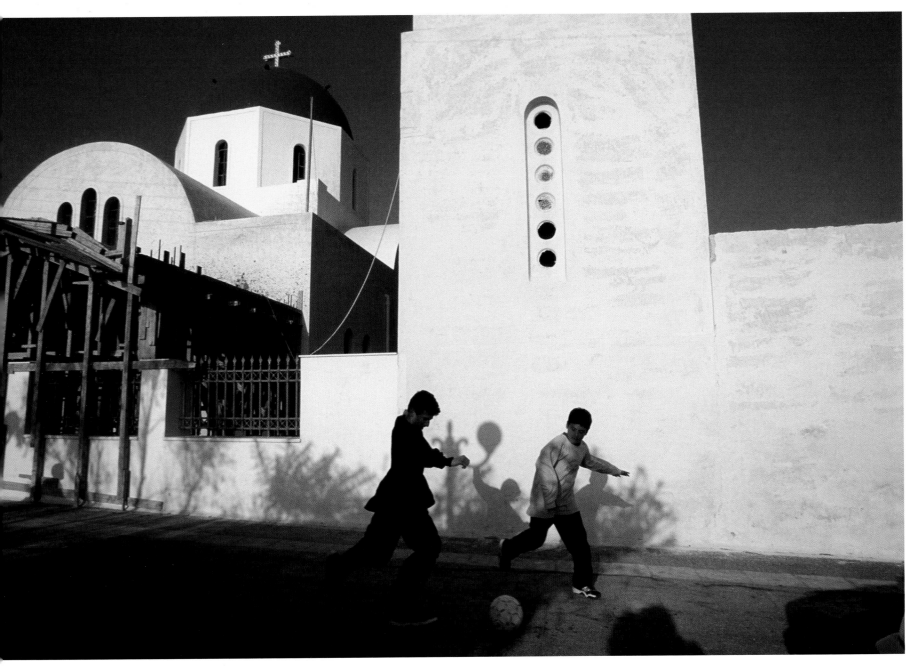

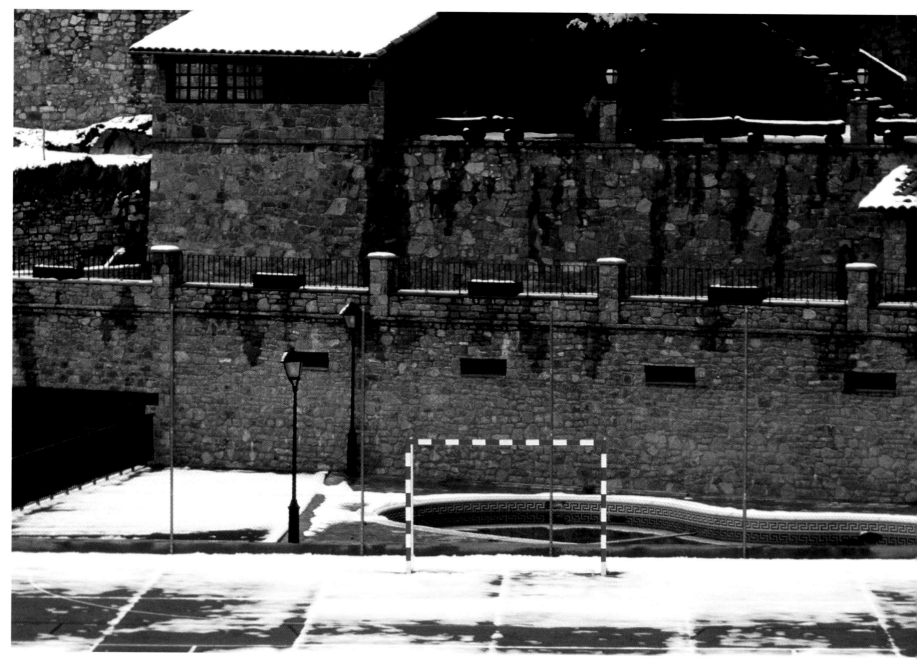

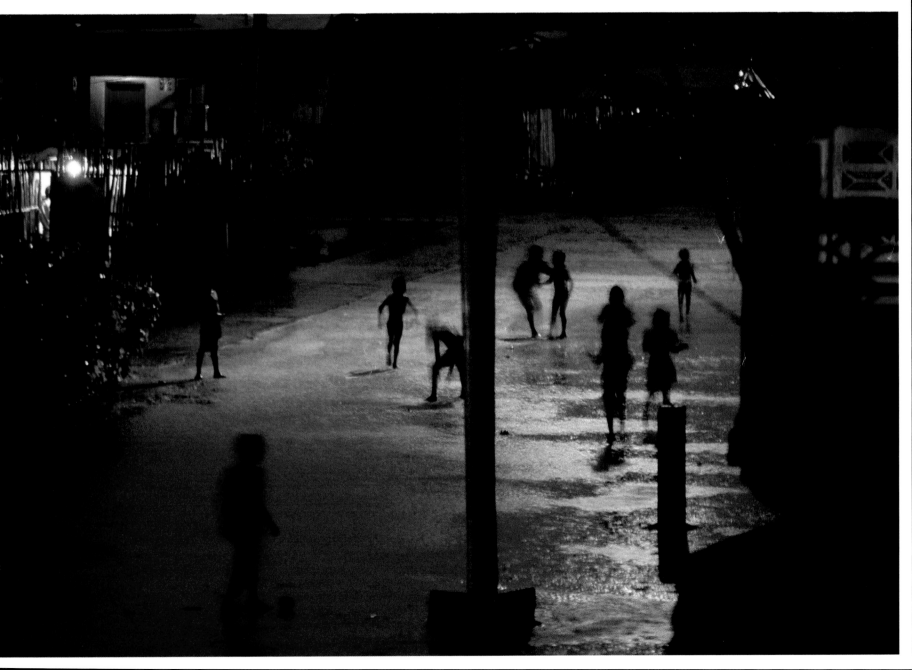

Nyika, Malawi

Poverty and climate harden both the skin and soul. So when the chance arises to score a goal, you feel no pain, even though you're kicking a piece of wood rather than a ball.

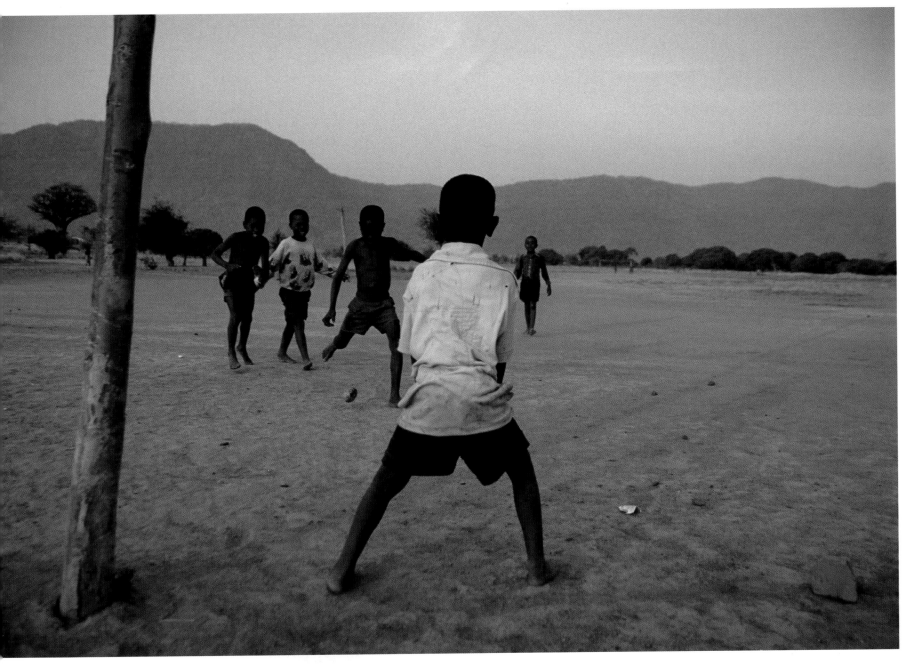

Tahiti, French Polynesia

The saying goes that you sometimes can't see the wood for the trees, but the pitch is clearly enough delineated amid the forest on this idyllic tropical island.

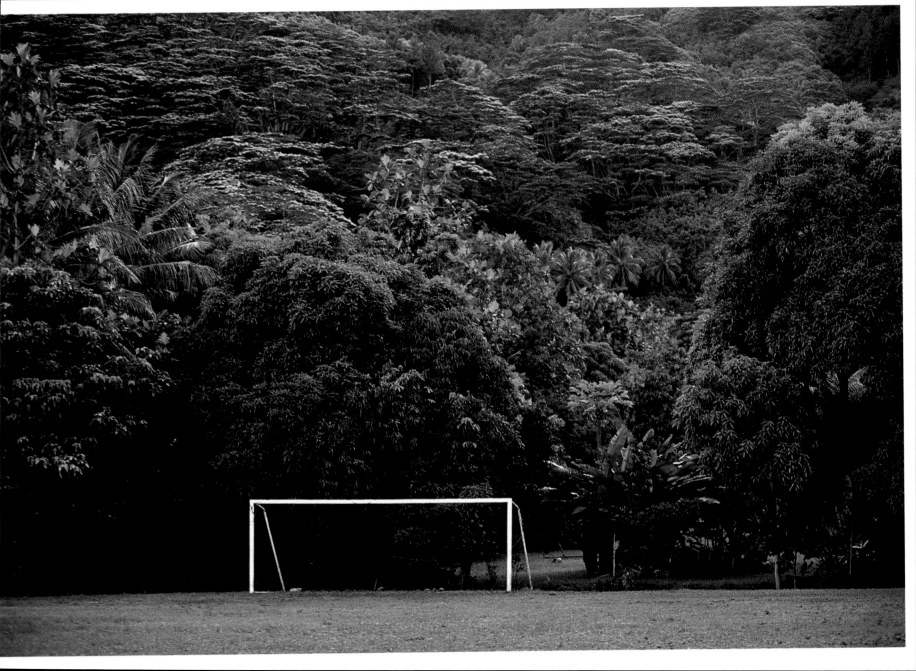

Llanos de Moxos, Bolivia

Fitting a whole family onto a bike can be a tricky business, but it's easy compared to the skills needed to keep control of the ball while dribbling it between two opponents.

Following pages (left and right):

Markina, Basque Country, Spain

You can imagine the players coming on to the pitch from the sidelines, still wearing their traditional berets and carrying a ball made of rawhide. These hamlets in northern Spain still preserve traditions from an age gone by.

Madhya Pradesh, India

In all religions, including football, there are things which amount to sacrilege. Whoever let this pitch fall into such a state of disarray should be excommunicated from the game.

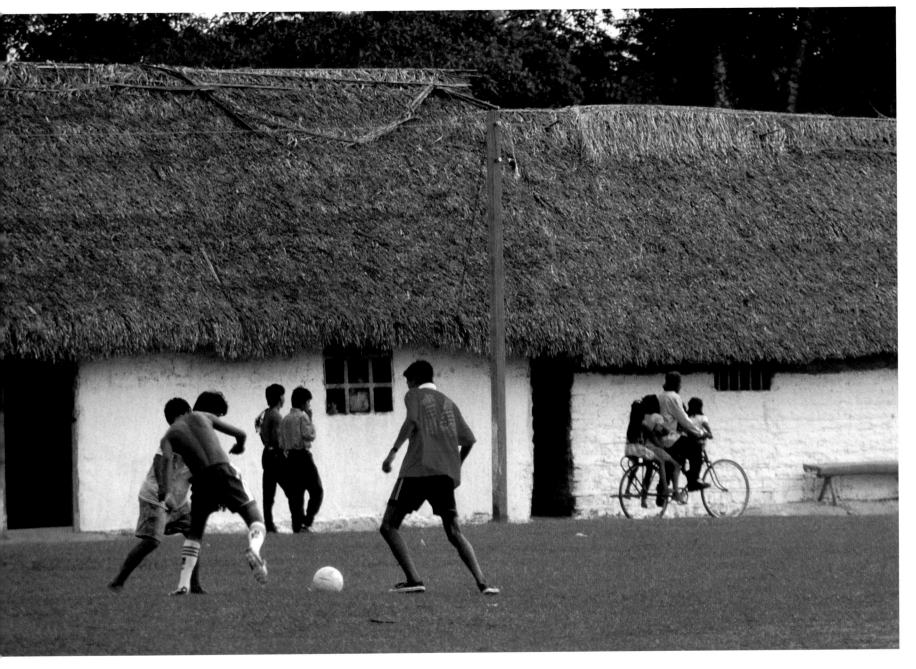

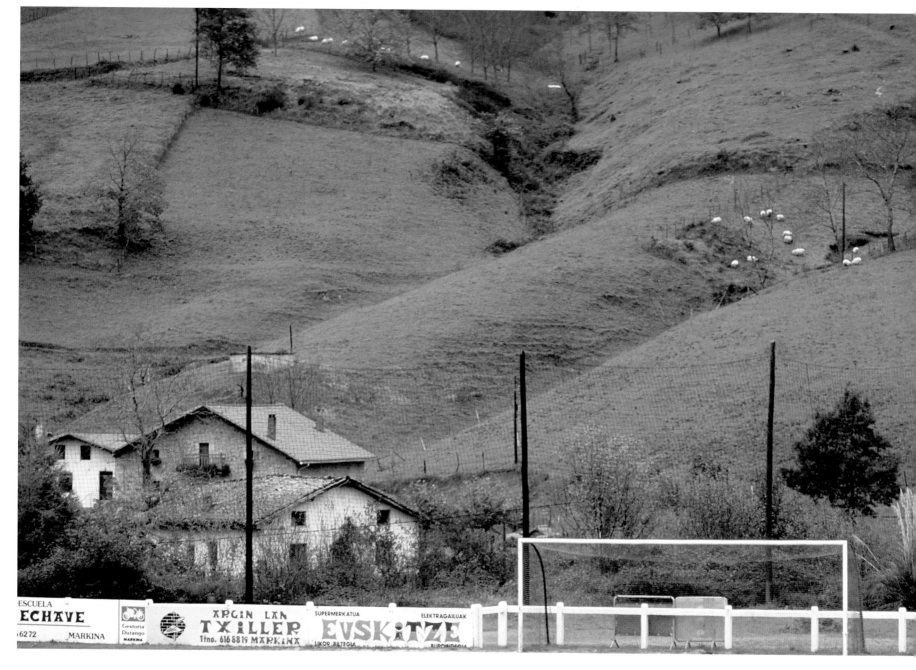

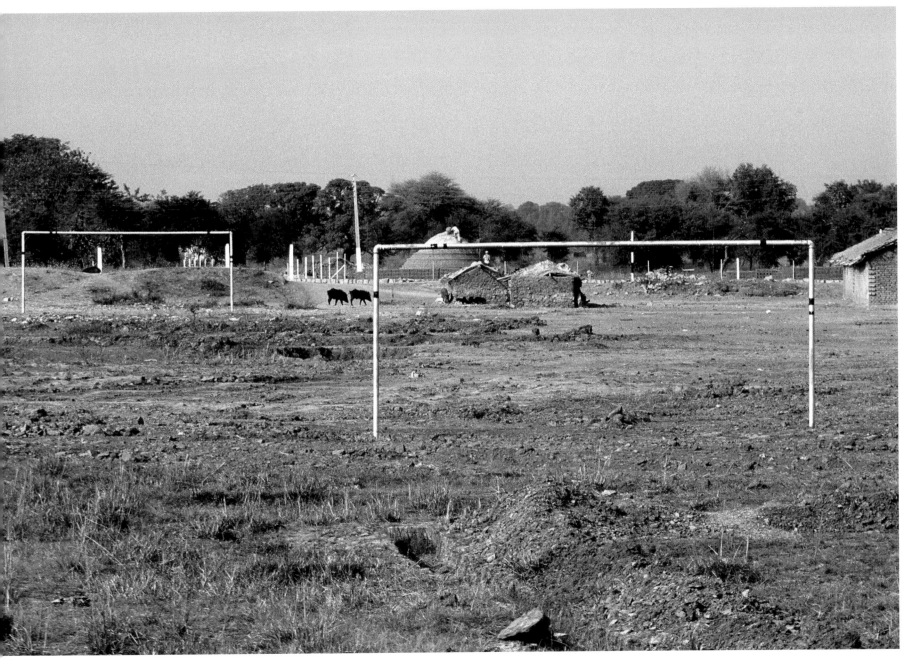

Katmandu, Nepal

The goalkeeper makes a powerful clearance. He doesn't want to take any chances, perhaps because he suspects that scouts from the local football federation could be looking on, and he is desperate to be asked to become one of the forty best under-twelve talents who will shape the future of football in his country.

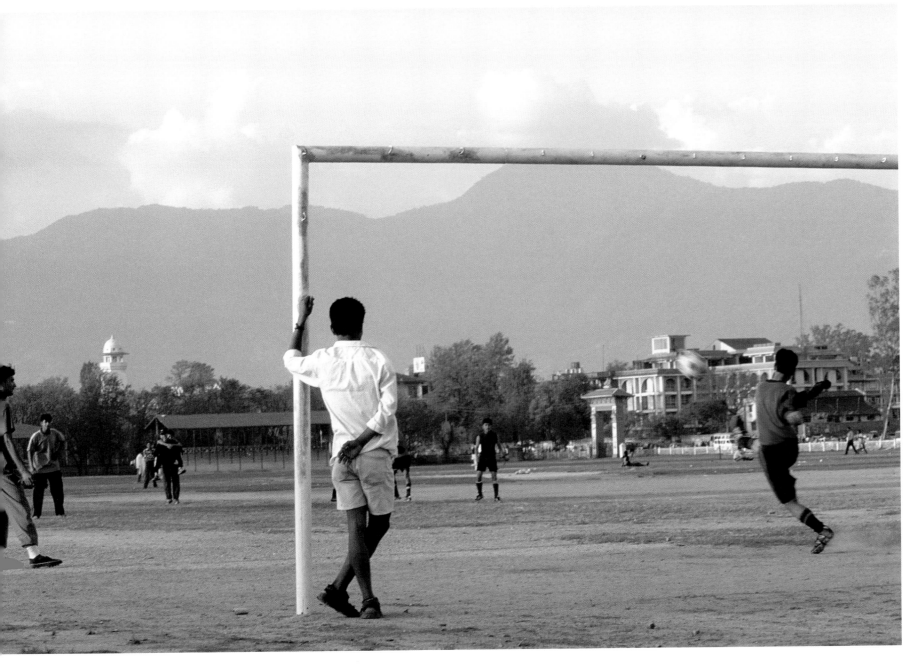

O Rosal, Galicia, Spain

Despite the uneven terrain, the green grass almost invites you to play. But with no game in prospect, even the dog looks bored.

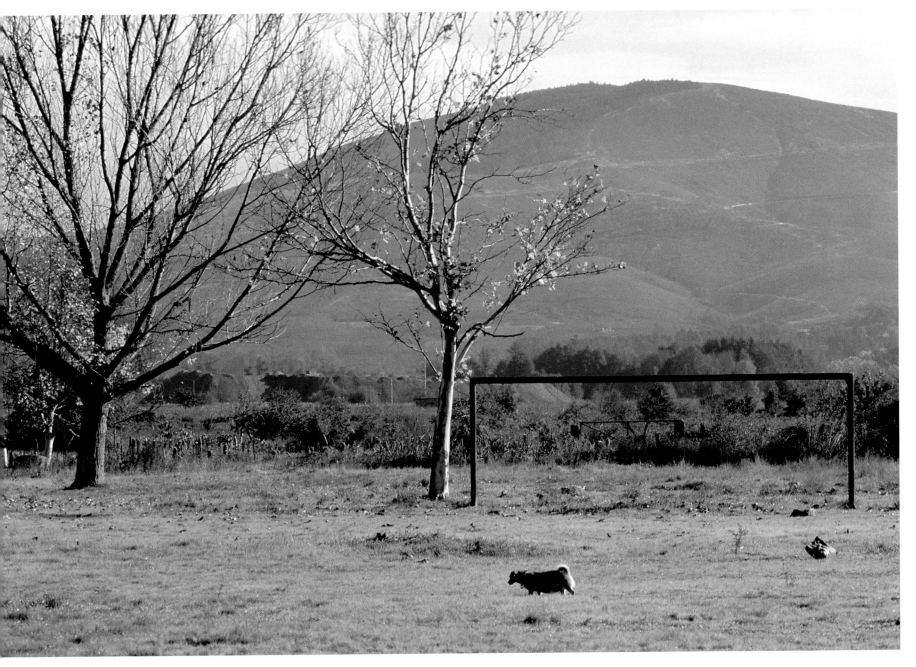

West Bay, Roatán, Honduras

When the ball is kicked a race begins in which there are no handicaps to allow for age or gender. But whoever wins will feel on top of the world for a fleeting moment.

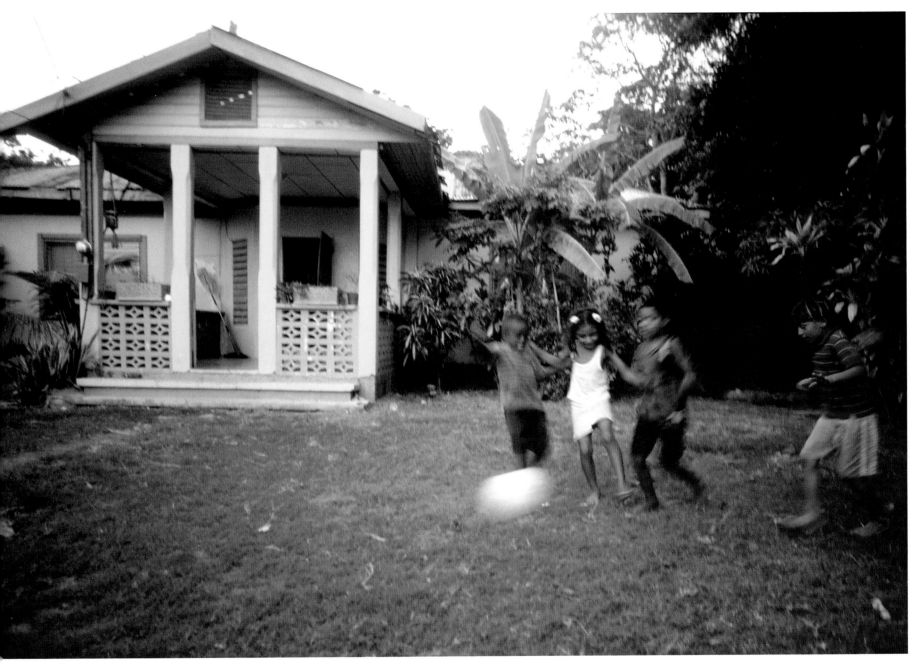

Ustupo, San Blas Islands, Panama

The girls are headed for home while the boys pass by on their way to the beach.
These are Kuna Indians, who zealously defend their way of life and natural environment.
But the prospect of football at sunset bridges all cultural gaps.

Following pages (left and right):

Colón Island, Bocas de Toro, Panama

The crisp right-footed shot is aimed straight for the photographer's nose sticking through
the fence. It's just practice for the day when this young player will take part in an all-star
match on this Caribbean island's humble little pitch.

Panama City, Panama

In the middle of the old town, partly obstructed by a kerb, kept clear by a no parking
sign, with an audience of listless idlers, football is being played. A reminder that the game
belongs to the people and the street, and will continue.

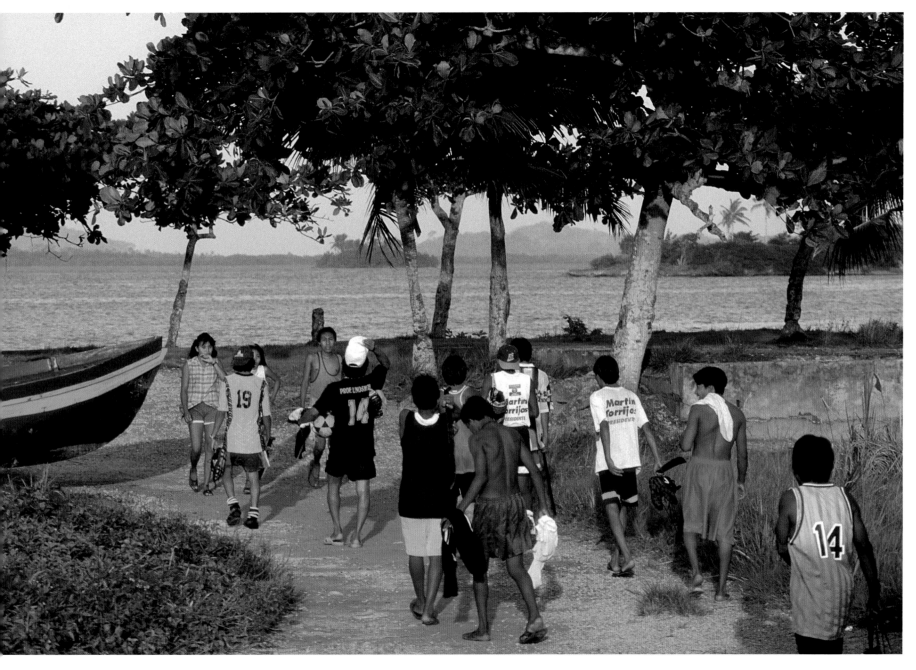

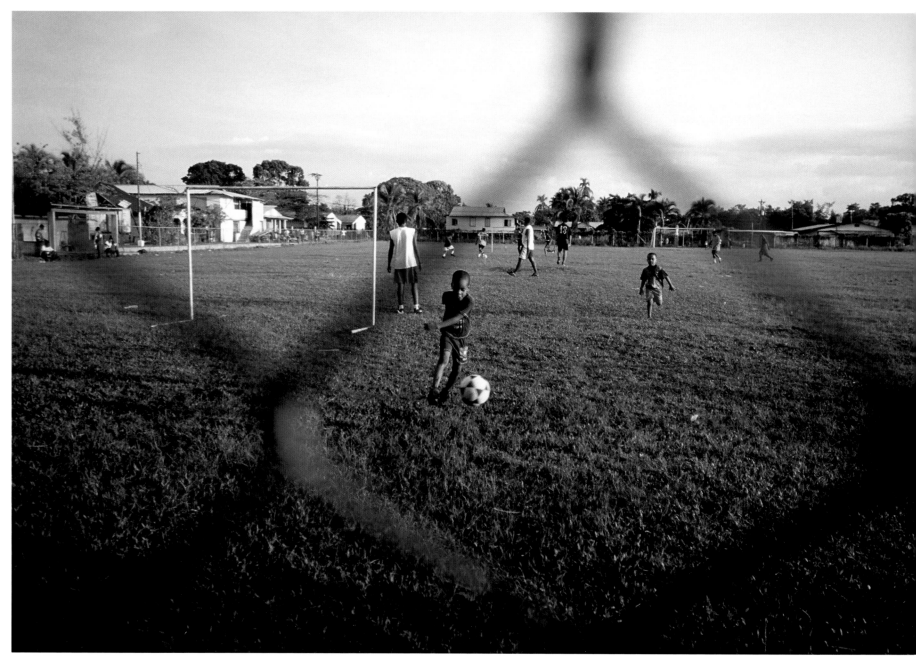

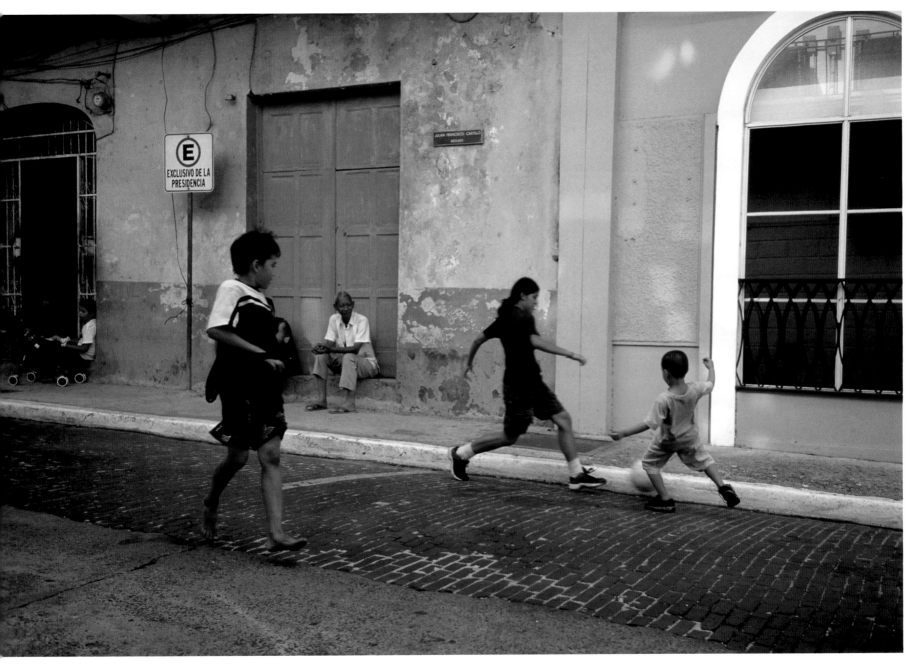

Reykjavik, Iceland

No Icelander in his right mind believes that his country will ever reach the World Cup finals. Nonetheless, the streets here are as empty as anywhere else in the world when the national team is playing a qualifying match.

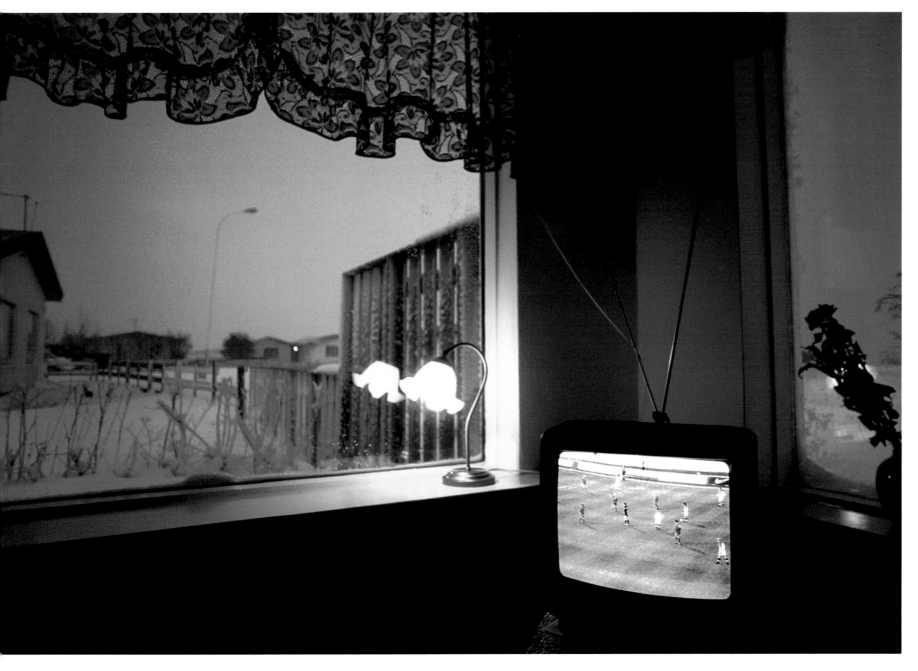

the goalkeeper

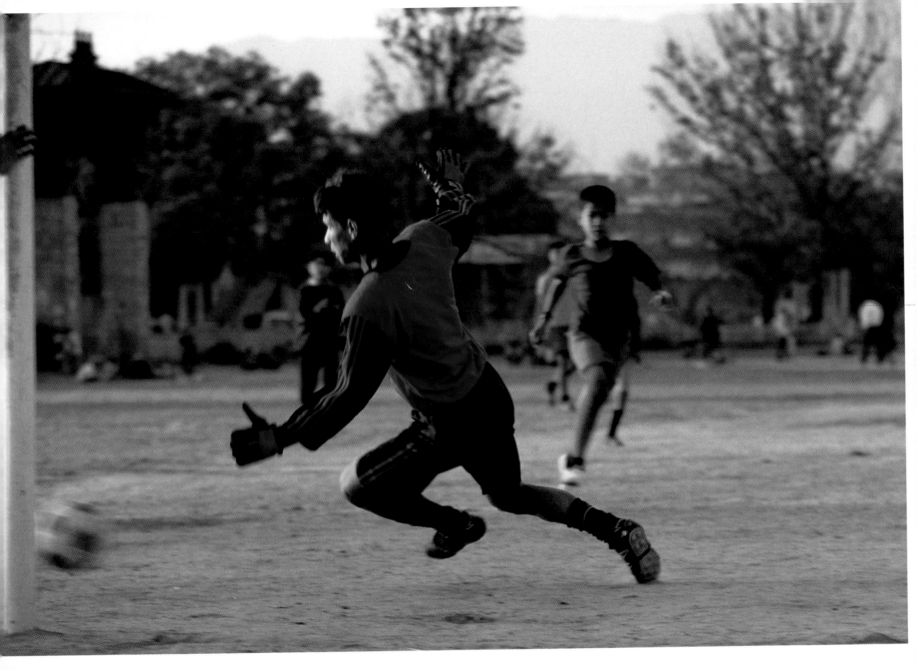

After several years of research, involving interviews, analysis and careful consideration of the evidence, a German university department with an unpronounceable name finally came to a definitive conclusion: most goalkeepers suffer from mental imbalances. More precisely, 57% of the cases studied displayed 'some form of neurotic disorder', 8% were affected by 'significant behavioural pathologies', and 2% suffered from 'borderline personality disorders', a condition characterised by sudden mood changes and self-destructive behaviour.

Sitting at a table in the bar opposite the ground belonging to Testaccio, a small neighbourhood club in the suburbs of Rome, Filippo Bonvecchiatto considered this finding, shrugged his shoulders and knocked back another shot of grappa. Less than three weeks earlier, during one of those regular end-of-afternoon football get-togethers, Filippo had proclaimed:' *I portiere sono tutti matti,*' which can be roughly translated as 'All goalkeepers are crazy.'

The German report, characteristically methodical and Prussian, was based on seemingly irrefutable data: 847 goalkeepers from the top three leagues in five different countries had taken part in the study. Sports doctors, psychologists, endocrinologists, lab technicians and expert statisticians had done lengthy interviews, carried out electroencephalograms and brain scans, conducted clinical analyses and sensory tests and compiled tables. The data had been methodically set out under headings covering the different categories of mental disorder: neurosis, paranoia, bipolar disorders and so forth.

Previous page
Katmandu, Nepal
The goalkeeper is committed, his body is braced to receive the stinging shot, his mind resigned to a pair of scraped knees. Goalkeepers have a vocation to be heroes, lonely and too often misunderstood.

Filippo Bonvecchiatto's evidence was more empirical, based as it was on many years spent observing promising young lads as they passed through the Testaccio talent mill and chatting with them at the end of training sessions or before matches. But his conclusions were identical to those the Germans had come to. It was his view that anyone who took up a game whose very name, football, indicated that it should be played with the feet and then wanted to use their hands had to be at least slightly mad. Furthermore, in his opinion, only someone who was a bit soft in the head would choose to continually expose themselves to a firing squad, often made up of their own team-mates or even friends. He also believed that only someone with masochistic tendencies would be content to celebrate in the splendid isolation of his own penalty area when his team had scored a goal at the other end of the pitch. If these arguments did not satisfy those to whom he expounded his case, he would set out his elaborate theories on the psychological basis of goalkeepers' problems. These were, he suggested, rooted in childhood complexes and exacerbated by the humiliating experience of always being the last player picked for a team and the knowledge that one was often placed in goal not because of one's talent for the job but because of shortcomings in other respects: whether it was a lack of ability with the ball, a failure to ingratiate oneself with the leaders of one's peer group or just being overweight.

But while the German study left you with the feeling that all goalkeepers would benefit from being accompanied to every match by a personal therapist, Filippo Bonvecchiatto would at least conclude his monologues on goalkeepers by conceding: *'I sono matti, ma i sono buona' gente* – 'They may be crazy but they're nice guys.'

A few months later, a journalist published an article on a follow-up investigation the German university department with the unpronounceable name had undertaken in the light of the surprise generated by their original study. He wrote: 'Just as a few years ago, Brazilian coffee exporters sponsored a misleading study which concluded that drinking ten cups of coffee a day was good for your health; in this case, the work was financed by Jürgen Steitcher, failed Gelsenkirchen striker, who had four penalties saved by a goalkeeper on the day that the Bayern München coach had gone to observe him'.

It just so happened that, on that same afternoon, Giancarlo Bernardini, an old Testaccio resident now living in Switzerland, passed by the bar opposite the football ground. He spotted Bonvecchiatto in his usual place and there followed hugs, greetings and a prolonged exchange of anecdotes about the past that immediately drew the attention of the bar's regulars. But, as time went on, the regulars remembered only one thing that was said in the course of that peaceful afternoon, when Giancarlo asked, quite without malice, 'Filippo, are you still angry about Testaccio rejecting you as a goalkeeper?'

the feint

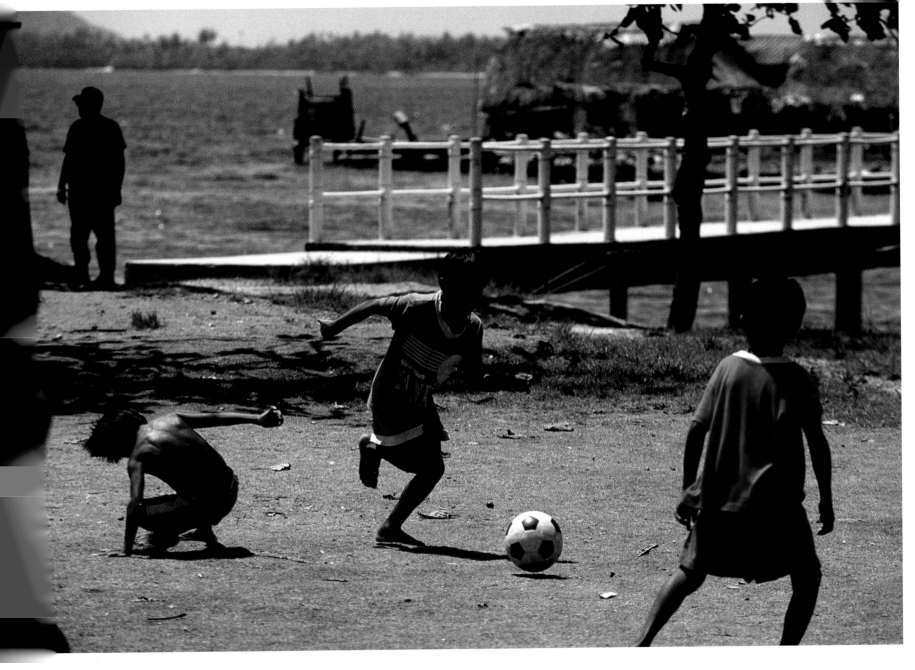

'Here you come again. What can I come up with now to leave you rooted to the spot, graceless, humiliated and disabused of any ideas you may have about taking the ball off me? For a start, look at my waist, observe its sinuous grace, doesn't it remind you of one of those odalisques from A Thousand and One Nights? Oh, don't get the wrong idea, I have no intention of seducing you, just of throwing you off track. My waist is a miracle of flexibility, elastic, hypnotic. We both know that it is also terribly deceitful, but I love trickery, and I know you can't resist its snake-like charms.'

'Here you come again. But this time it will be different because I won't fall into your trap. The ball, the ball – I know that I must concentrate on the ball; fix my eyes on it, never lose sight of it. I won't be misled by the movements of your waist because I am impervious to its wiles. Your waist is treacherous and deceptive, it gives out false signals which are intended to lure me into mistakes, mistakes which I am resolved to avoid this time around.'

'What do my legs look like to you? The sails of a windmill? A pair of clashing swords? My legs are carved from the wood of ancient footballers. They move with lightning speed, they pass over the ball without even brushing it, back to front, front to back. They advance, stop, then advance again. My legs fill you with doubt, paralyse you, hypnotise you. My legs are the

Previous page
Usupo, San Blas Islands, Panama
Looking at this kid, his gaze fixed on the ball, you can imagine his happiness. One opponent has been outmanoeuvred and, with a half smile creeping across his face, he is now ready for the next.

keys that will unlock your defences, the weapons that will open up a breach in your ramparts and carry me along the path to glory.

'I don't care how fast your legs move. I am not looking at them. The ball, the ball is the sole focus of my attention. You have it and I want it. This confrontation has many parallels with life: here we are, two opposing wills, two conflicting needs, two divergent objectives. This probably isn't the right time for philosophical musings, but at least they are an excellent way of not allowing your legs to distract my attention and lead me into your trap. I have already learned that in this situation, if not in the Wild West, the guy who draws first is a dead man, and it won't be me. Your move, cowboy.'

'Observe my ankles, they are made of flexible and malleable rubber, they bend at will, changing direction unpredictably like drifting ships. While the sole of my boot traps the ball, mooring it to the ground, my ankle sows the seeds of confusion: it seems to suggest a move to the left, then switches to the right. A skilful pair of ankles are a gift to any footballer.'

'How difficult it is to avoid temptation when an ankle that moves so elegantly seems to offer the ball to you like an unexpected gift. I know that the gift is a poisoned chalice, that I should ignore the ankle and look only at the ball, but it's almost impossible to resist the temptation.'

'The waist, the legs, the ankle and the sole of the boot. Now everything is balanced harmoniously in a single composition. On the other side of the defender lies the penalty box, the goal, the celebration. To reach them all that is needed is a little art, a touch of exhibitionism, a flash of arrogance. A feint to clear the way to the opponent's goal is the very essence of football.'

'Not the waist, not the legs, not the ankle, not the sole of the boot – just the ball. The ball will be mine the instant you commit yourself to a move. Don't get me wrong, I'm not out to spoil your fun. I too am partial to beauty and expressiveness, but I am forced to look as if I want to spoil the show. Or maybe you think that defending requires no talent? Not so, I too need art, skill, intuition, dexterity, speed and precision. But in my case they are all focused on taking that ball away from the protection of your feet. The choice between us is just a matter of taste'

'It's time for the feint. Here I go. I'm sorry, there's no way you are going to deny me my glimpse of Heaven.'

'It's time for the feint. Here he comes. I'm sorry, there's no way you're going to get past me, This is my piece of Earth and I am defending it at all costs.'

the fan

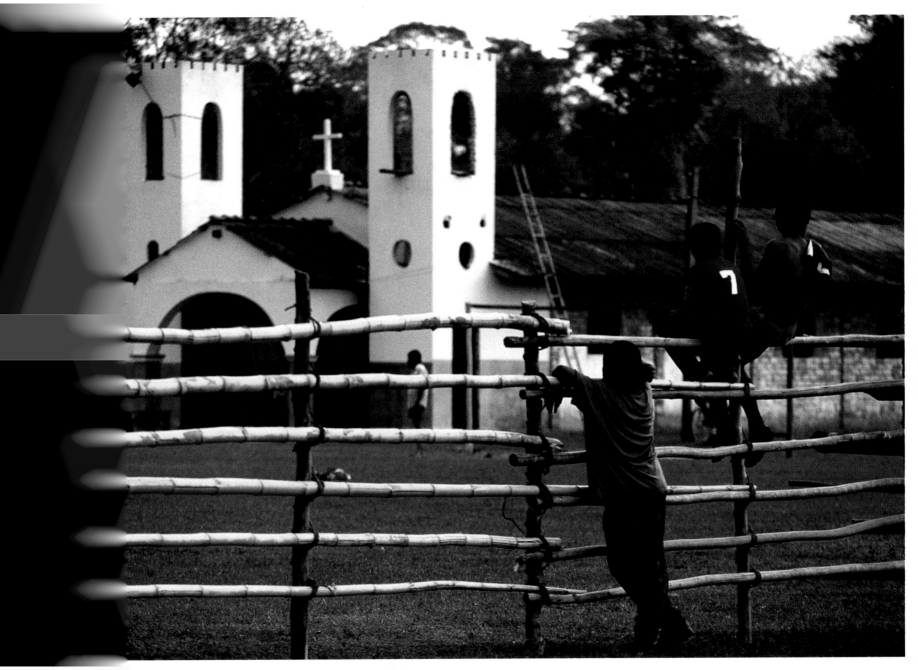

No one ever thought for a second that Sports Club Trinidade would end up playing in a final. Conceived around the tables of the Saudade restaurant, in the interval between the *feijadas* and the chicken, it was just the whim of a group of friends. It doesn't have its own stadium, its headquarters is the restaurant counter, and the players only have one set of shirts. None of this worries its enthusiastic and proud directors very much; the only thing they regret is their lack of fans. They have tried everything to remedy this shortage of grass-roots support, but all in vain. People just haven't connected with those green and white shirts that have graced the bottom league for seventeen years. Usually only around twenty faithful supporters turn up to take a turn round the pitch and give the odd shout of encouragement, more in the hope of getting a free dessert in the restaurant than out of any real loyalty to the club.

But unlikely things happen in football, and a few years ago Trinidade qualified for the final that could gain them promotion. It was during one of the tense preparation meetings for the coming clash that someone realised that, for the first time ever, the club's lack of fans would be a major issue. Their opponents, Desportos Sao Joao, would certainly be bringing two or three thousand ardent followers, and so great a disparity in support from the touchlines would not only have a negative effect on the spirits of the Trinidade players but would inevitably intimidate whatever referee they got. It was then

Previous page
Llanos de Moxos, Bolivia
The wooden fence isn't the most comfortable of seats, but it doesn't matter to the spectators. The neighbourhood team, their friends' team, is playing on the church's little pitch and they are determined to provide support.

that Trinidade's treasurer came up with a brilliant idea: why not hire some fans? At the time, it was common knowledge that Maritimo, another club in that division, had scores to settle with Desportos Sao Joao, and would therefore welcome an opportunity to root for Trinidade – providing they were offered the right price. There was no time for discussion, and just 48 hours later an agreement was reached. That Saturday, 300 Maritimo fans would trade in their shiny blue banners for the green and white of Trinidade.

Sao Joao's fans could hardly believe their eyes when they saw a rowdy column of supporters stream into the stadium, brand new flags at the ready, singing Trinidade's praises. But there they were, jumping up and down as if possessed, dancing as if was Carnival time, cheering when the green and whites came out of the tunnel and booing the yellows of Sao Joao. So great was the surprise that, initially at least, Trinidade's 300 fans seemed to outnumber *Sao Joao's* 2000-odd. In the director's box, Trinidade's treasurer held his head up high.

The final, as often happens, ended up being boring on the pitch but passionate on the terraces. The Sao Joao fans were determined to make their superior numbers count, but those from Maritimo/Trinidade resorted to all sorts of special effects to make up for this: they shouted louder, never stopped waving their arms, banging their drums, stamping the ground, and vigorously waving their flags. This show went on for 85 long minutes, by the end of which time, given that nothing much was happening on the pitch, most of those present were paying more attention to the dance moves and chants of the green and white supporters than to the game itself; even the Sao Joao fans, who had resigned themselves to the fact that the opposing crowd was going to continue displaying more passion than they could muster..

It was at that moment that the final reached its climactic moment. At first it seemed to be just a trick of the light played by the setting sun, but it soon became clear that the phenomenon was real. The sweat of the fervent rent-a-fans had turned a bright and radiant blue. With every passing second, every shout and jump, the indigo-coloured beads of sweat gushed more abundantly from their foreheads, armpits and shoulder blades. Sky-blue streams began to trickle down their bodies and in just a few minutes, flags, drums and even the concrete of the terrace had been stained blue. It was an intense, deep, marine blue – a Maritimo blue. Just at that point, when everyone was staring, open-mouthed, at the inexplicable events on the terraces, the unscrupulous Sao Joao centre-forward took the opportunity to score the winning goal. While the yellows celebrated gaining promotion, the green and whites' bewilderment turned to sadness and Trinidade's treasurer buried his head in his hands. Meanwhile, on the newly blue terraces, the party continued as if nothing had happened, as if the feverish people there didn't really mind what had been happening on the pitch.

the style

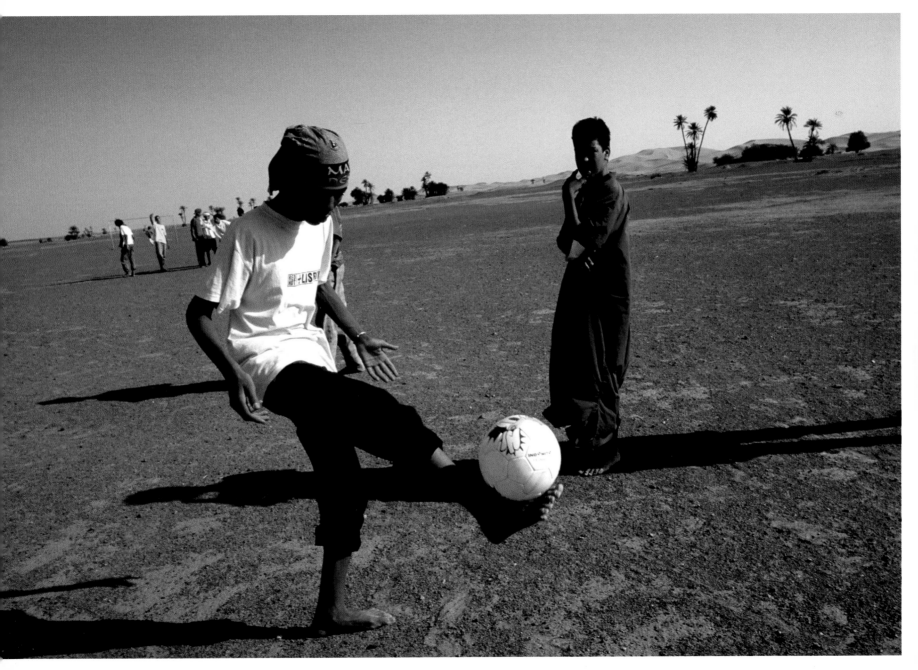

In Malvín, a Montevideo neighbourhood bordering the South Atlantic where the writer Eduardo Galeano lives, there is a unique and distinctive road sign. It's a warning sign, similar to those that alert drivers to the fact that there is a school nearby and that a group of kids could suddenly step out into the road. But this sign doesn't draw your attention to schoolkids, potholes or wild animals that might gallop across the road at any moment: the sign is there to announce that children are likely to be playing football in the area.

Rather than being an example of local eccentricity, the sign is an acknowledgement of Uruguay's glorious football history, a symbol of national identity and, above all, a mark of respect for the Uruguayans' unique way of seeing, understanding and relishing football. Here, no one would dream of taking the trouble to alert travellers to the proximity of a game that was being played without due solemnity and respect. No way.

It's certainly the case that in recent years national styles of football seem to have been losing their distinctive character as the game has fallen victim to the well-documented phenomenon of globalisation. But this is

Previous page
Merzouga, Morocco
Only someone in love with the ball could possibly caress it so delicately with his instep..

only half true. Even today, contemporary photographs prove that the style genes still live on in players of all nations, expressing themselves in the measured movement of a black African, the electric leap of an Asian, the hefty stride of a Central European or the slovenly rhythm of a South American.

One could argue, correctly, that the world has seen exquisite footballers who were born in places not renowned for their football prowess like Finland, Latvia or Saudi Arabia; and, by the same token, that there are many Brazilians, Italians or Cameroonians, for example, whose lack of skill with the ball is positively elephantine. But such exceptions only serve to prove the more general rule; which is that a player's inherited national style transcends his individuality. That is why there are such striking differences – although these are later smoothed over in the factory of professionalism – between the direct and frontal play of the British, the anarchic dancing of the Sub-Saharans and the passion with which players from South America's Southern Cone insist on keeping possession of the ball at all costs. This remains the case because people learn, from the cradle onwards, to feel, understand and like the game in different ways They fall in love with their own local heroes, emphasise different aspects of the game, imitate the moves of more experienced players with whom they have shared a game while cutting their footballing teeth on the school pitch or town square.

We acquire our football style like mother-tongue, absorbing what is around us without being conscious that we are learning. That is why, despite the homogenising effects of globalisation, national style still exists. It manages to manifest itself in the head-held-high poise, toned body and smooth instep of a boy from Lima; it is reflected in the sense of excitement felt by a fan from London when his team wins a corner; it is what causes an Argentine to swear blind he'll pass the ball back to his team-mate, who then returns it with it with a paradoxical 'Take it'. And a genuine national style is what you are encountering when you round a corner in a Montevideo neighbourhood to find yourself looking at that road sign which some sensible person put up to encourage people to drive carefully here, because something is happening that demands the utmost respect: children are playing football.

the goal

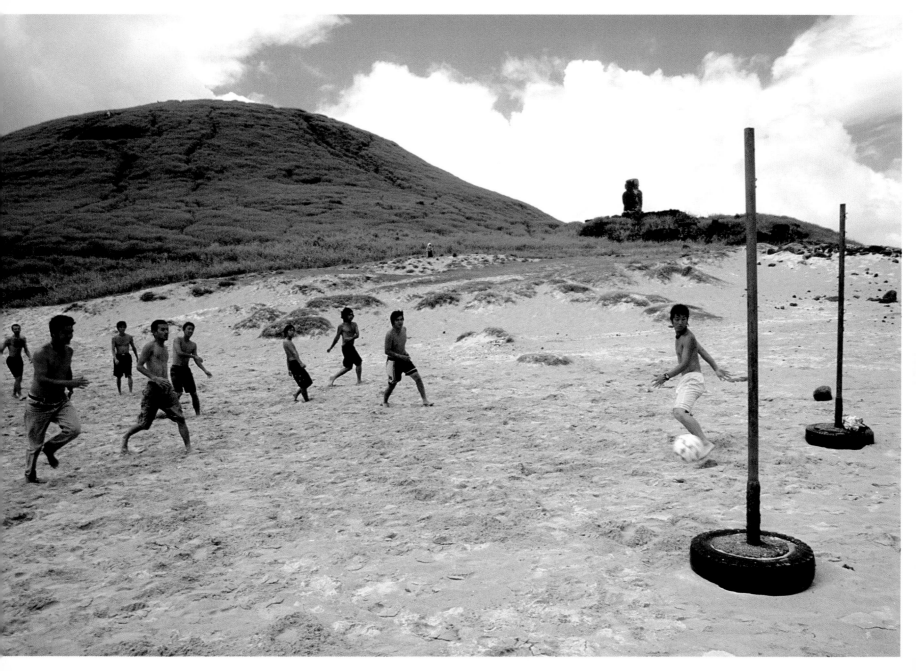

Anakena, Easter Island
In the background, the right foot of the guy who took the shot lands in the sand.
The goalkeeper is left rooted to the spot. Defenders and attackers stop in their tracks.
It's a goal, indisputably a goal. Even the *moai* statue on the hillock would also join in
the applause if it could.

By the age of fifteen, Horacio Robledo had developed a personality, on and
off the football pitch, that was diligent, upstanding, irreproachable, sensible,
quiet and even somewhat boring. Thin but not lean, intelligent although
extremely shy, both curious and easily scared, he was more inclined to follow
reason than act impulsively. In fact, you could say that Horacio was well
suited to the role of no-nonsense central defender. When he was at school he
always got top marks. On the pitch he won balls in an understated way, with-
out complications or taking risks. At home he would accept decisions and
even eat food that he hated simply to avoid provoking arguments or domes-
tic dramas. On the football field he would always look for the nearest team-
mate as soon as possible in order to rid himself of the ball.

That was how Horacio was, and that's how he continued to be until one
run-of-the-mill match on a cold and rainy Saturday. Nothing in particular
had happened to him the night before: he had had no dreams or premoni-
tions. There was nothing special about the morning, he enjoyed his usual
breakfast of chocolate milk with bread and jam, there was no indication
that this day was to be different from any other Saturday. Nor was there
anything special about the first hour of the afternoon's friendly match
against a team from a nearby neighbourhood.

The encounter was playing out predictably, and if anyone had defied
the rain and stopped to watch they might have even said it was quite

entertaining. Estudiantes de Flores, the team that a group of football-mad school friends had founded two years before, was the better team and was winning 3-2, while, Horacio displayed his handful of virtues and his well-known defects on the muddy park pitch. He held back, waited, watched the back of the right-back or his partner in the centre of the last line of defence, he waited for the opposition's attack to take shape and at the last moment, when conceding a goal looked increasingly likely, he stuck out the tip of his boot and tried to avert the danger, something which, it has to be said, he did with variable success. For nobody should be under the impression that we're talking about a defender destined to make history, just a simple, honest dreamer; a stubborn footballer whose passion for the game had persisted in the face of cutting remarks and numerous humiliations and won him the respect of his team-mates and a place in the starting line-up.

In the opening minutes of the second half, the most noteworthy event was that the rain stopped. Then there came a seemingly innocuous move in which one of the opposing midfielders decided to attempt a long cross-field pass from the left. Horacio got in front of the attacker and cut out the ball with the outside of his right foot; as so often before it bounced once and landed a few metres away. Horacio ran after it, managing to note that Miguel, the right winger, was unmarked, and passed it to him. And then, totally unexpectedly, going against everything he had ever done before that supreme moment, Horacio continued running, totally unconcerned about whether he was leaving the defence wide open or whether an attacker had been left completely unmarked. Illuminated by the comforting rays of sunshine that were breaking through a crack in the overcast sky Horacio crossed the half-way line while the winger made his way forward to the right. Horacio broke into the opposition's penalty area with unwonted determination, as if someone or something was willing him on. The cross, when it came, was so measured that he didn't even have to jump, the header was a clean contact and strong and it went in impeccably, high up, just brushing the underside of the crossbar..

What sparked such an extraordinary event? Who pulled the strings of destiny? Was Horacio responding to some inner voice? Was his action the first blow in a rebellion against an existence in danger of becoming monotonously grey? We'll never know, but what's for sure is that since that routine Saturday game Horacio has never again held back from crossing the half-way line, either literally or metaphorically, shouting, taking a chance when he felt it was necessary. Something had been changed for ever by that enlightening, surprising and, for the rest of the universe, insignificant, header that was destined to be a goal.

the dreams

The day that my father first gave me a shirt in the colours of our beloved team, he unwittingly cast a spell. The shirt was made of shiny red cotton, with white collar and cuffs and had a number 9 sewn on the back. It didn't have any fancy bits, because that's how football shirts were back then, no well-known brand-name, no surname above the number, no sponsor-of-the-moment's logo stamped between the nipples, and I seem to remember that it didn't even have the club's name on the left chest, by the heart; but it was a marvellous shade of blood red. However, what really made that shirt a special and irreplaceable garment was the stitching which, to my astonishment, was full of magic. How else could you explain the fact that every time I, a small boy, slipped it on I was transformed into my hero, the man whose goals made me so ecstatic when we listened to matches on the radio in the afternoon, the man who smiled out at me from the pages of my sticker album.

As you'd expect, it took me a long time to get my head around it. The time it would have taken any child to work out that, whether awake or asleep, when he dreams of his favourite footballer he dreams not of imitating or emulating his hero, but of *becoming* him. What the dreaming

Previous page
Tokyo, Japan
Pieces of coloured cloth with numbers and names on the back bridge the gulf between football's two extremes. For every fan who pulls on his idol's shirt dreams of absorbing his magic, of bathing in his glory, and is happy.

child wants to do, simply, is to 'be' his idol, so that their bodies become one, and they take on one and the same identity.

It is worth clarifying at this stage that I was helped to this conclusion by another surprising event: as I had grown out of the original shirt it had to be replaced by another one, new and gleaming red, this time with a number 10 on the back. When I wore this shirt, and only when I wore it, mind-boggling football phenomena occurred in the courtyard of my house. For example, I found that I, a player you would barely rate as 'reasonable', could advance with the ball stuck to my feet, elegantly dribble round a chair, knock it through the table legs and then, using the outside of my right foot, send it delicately through the bathroom door, glancing it in off the doorframe at the exact point where it met the floor. You may well think that such a sequence of accomplishments, though surprising, was just a coincidence, but what happened next raised my suspicions that something funny was going on. As soon as the ball hit the bathroom curtains, which flapped to applaud the goal, the hoards of invisible people who always turned up punctually to witness my solo performances – all those fans who squeezed into bedroom doorways, clambered up the ivy on the back wall, hung over the stairway leading up to the terrace – broke out in a shout. But they didn't yell, as you'd expect, 'Ro-Ro-dolfo!', or something along those lines. No. They chanted 'Bo-Bo-chini!', the surname of the true owner of my cherished red number 10 shirt. But, nevertheless, I knew it was really me they were acclaiming; so I would kiss my red shirt and wave to the stands with my chest puffed out, happily metamorphosed into the player I'd always dreamed of being and had finally become, there in the intimacy of my family's courtyard.

People say that kids these days are less innocent, that they quickly get their heads around things like marketing, the Internet, branding and other elements that enmesh today's football in the business world. They may well be right, but I'm convinced that, just like those thirty years older, the lad from a Rio de Janeiro suburb who pulls on a worn out Ronaldo shirt doesn't do so in order to copy him: in that moment, pure and simple, he 'becomes' Ronaldo, he faces rivals with equal determination, breaks into the penalty area with just as much ferocity and celebrates goals with the same mischievous boy's smile. I am convinced that the magic that my father gave me with that first shirt is still alive, working just as effectively for a new generation of young hero-worshippers.

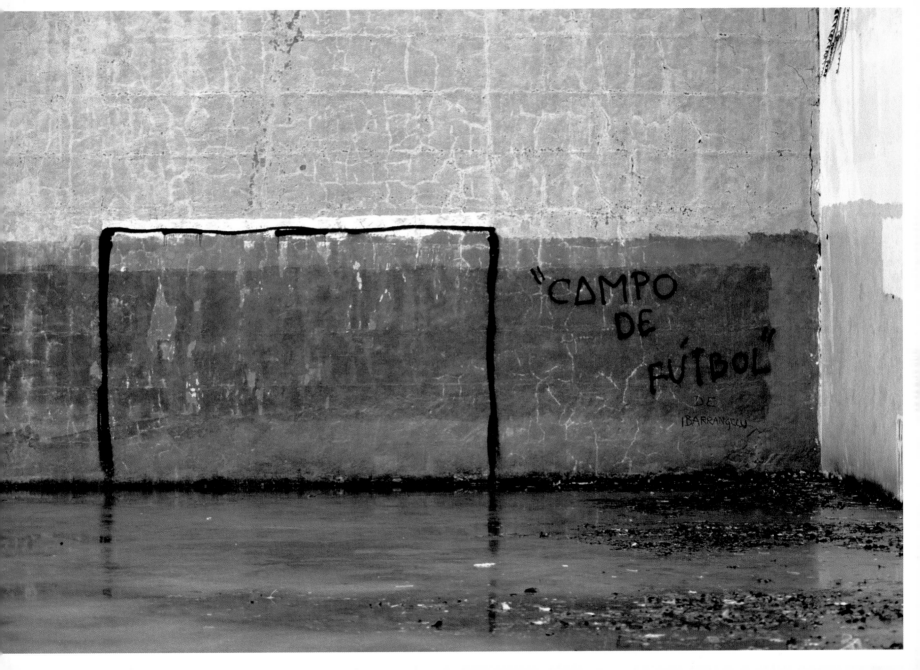

rodolfo chisleanschi

There are those who say that football journalists are frustrated players. In my case, there's no doubt about it.

In my childhood I always dreamed of playing in the First Division. I never made it, but I found other ways of binding myself to football. For example, in my native Buenos Aires I was the club doctor for a Second Division team and worked as a journalist for the newspaper, *La Razón* and for the Belgrano and Excelsior radio stations. Later, my adoptive Madrid gave me the opportunity to train an indoor football team of visually impaired players, continue my journalism with *Don Balón* magazine and, since 1996, work as a sports correspondent for the Argentine newspaper *Clarín*.

But since a man cannot live by football alone, I also wrote on other topics for *Cambio 16*, *Muy Interesante* and *Playboy*. And in 1989 I penned my first article for GEO magazine, where I am currently Deputy Manager. In its pages my eyes take a monthly peek at the world, and invariably come to rest on a place where a boy is to be found nestling a ball under his foot.

andoni canela

What came first, football, photography or the desire to travel the world? The answer lies in the *Athletico Bilbao* shirt that my grandfather gave me when I was just five years old. But also in the kick-abouts with my father and brother in the family orchard or my time with the junior team of *C.D. Tedelano*, the club from my home town in Navarro. The longing to travel and take photographs came later.

It began at the end of the 80s, when my interest in nature and anthropology led me to Africa. Soon after, the hobby became a profession and since then I have travelled to around fifty countries putting together reports that have appeared in publications such as *Magazine de la Vanguardia*, GEO, *National Geographic*, *The Times*, *L'Speccio* and *Newsweek*. In many of the places I have visited, from Alaska to Polynesia, I have not only taken photos but also played football. From those matches I have taken away memories of remote landscapes, fun moments, team-mates and more than a few great goals that took me back to the afternoons of my childhood.

acknowledgements

To Leopoldo, Cristina and María, who made this book possible.
To Emilio and Edith, to whom we are indebted for designing the pitch on which this match was played.
To Jorge Valdano for his unconditional kindness.

FROM ANDONI

To the *La Vanguardia* Magazine team, and especially Sergio Heredia, for throwing himself into the article that would later give rise to this book.
To Pepe Baeza, for his support, critiques and inspiration. To Meritxell, for joining me on many trips and waiting for me during so many others.
To my father and my mother, for allowing me to turn the house's corridors into my first football pitch. To my brothers, Luis and Iñaki, for the first passes, shots and goals.
And to all those with whom I have shared good times behind a ball and who, in one way or another, are also protagonists of this book.

FROM RODOLFO

To my old man, who infected me with the football virus the day he put the first ball between my feet.
To Tatiana, for cheering me up every day, making me mad at times and, above all, for being a wonderful daughter who, of course, plays football.
To Juan José Panno, soulmate and journalist who asked me in a taxi in Buenos Aires one day, 'And why don't you put together a book?'
To Estudiantes de Flores, Deportivo Armenio and the teams from the O.N.C.E. Madrid Regional Division.
To GEO magazine, in whose edition number 184, of May 2002, this book's introductory text was published.
To those who supported me with the writing and helped edit the texts.
To all those who taught me to love, understand and live football.